ALBERTA BOOK

ALBERTA BOOK

PHOTOGRAPHS BY GEORGE WEBBER

WITH CONTRIBUTIONS FROM FRED STENSON AND ROSEMARY GRIEBEL

RMB

This book is dedicated to my sisters and brothers
Pat, Mary, Marge, Em, Jim and Chucker.

Sincere thanks to RMB, especially publisher Don Gorman
and designer Chyla Cardinal, for making
this beautiful book a reality.

ALBERTA SMALL TOWN
BY FRED STENSON

An Alberta small town is a bit like a person trying to tell a good story when listeners have grown impatient. Before the story gets to the good part, they're all checking their cell phones for messages. George Webber is the listener that storyteller wishes he had: the one who is listening well and deeply, and has the means and the art to carry the story forward in a faithful though different and perhaps better way.

The photographs in this book contain reflections and traces of a small-town Alberta that I am old enough to have grown up in. I may not be quite old enough to have seen the advertising signs nailed to the wall but I'm old enough to have seen the signs before they weathered and people shot at them; old enough to have watched movies at a drive-in theatre that hadn't been there for decades. I was young when cars were long and every Alberta town had a grain elevator.

These photographs make bittersweet art of the ambition that fuelled those towns. The quiet voice of that art is telling me, "What you're looking at right now will also fade to a trace. But, hey, it might be a beautiful trace."

George Webber was born in the mining community of Drumheller. My own hometown, the place where I went to school from grade four to graduation, was Pincher Creek. Both towns are from an early horizon of Alberta's town-building history. My small town is what I think of when I think about home, when I imagine the path I pursued or just followed while growing up. My point, if I have one, is that you can leave a small town—it's a free world—but the small town never quite lets go. No matter how slick and urban you think you have become, your small town still has an image of you that really *is* you, in some honest and not always flattering way.

One Alberta answer to the question of what a small town is might be that it is a town that hoped to be a big town. In my perusal of the subject, I've learned that most towns are born of the surge of a new economy. The people who came arrived dreaming of a fine new life, in which their own prosperity and the town's would grow in tandem. It would be silly to say all Alberta's small-town people were happy people, but not so foolish to say that each town was once a place of hope and aspiration. Towns begin in yearning, and boosterism, and in the long run of history become the fulfillment or remains of such hopes and dreams. Many Alberta towns have become windy, echoing memorials to what propelled them into existence. But even in the ghost town or the shrunken town, traces of love and fellowship remain. Both growth and collapse are embodied there.

The way Alberta towns came into existence is interesting to me, and I will focus there. But first I want to consider the thousands of years before Europe paid its first call. To say there were no towns then seems both obvious and untrue. In pursuit of food, inland First Nations were ever on the move, but when they set up camp, was that not a settlement? In each temporary place, they carried on their family and ceremonial lives. The big summer gatherings and sacred ceremonies like the Sun Dance were settlements, as were the gatherings at the foot of the buffalo jump. The fall of buffalo over the cliffs took months to prepare and culminated in intense communal work: skinning, butchering; the conversion of bison into clothing, shelter and portable protein. Fishing camps and wintering camps were settlements too, or so it seems to me.

European influence came to future-Alberta with the fur trade. In 1670 the Hudson's Bay Company received a Charter from English King Charles II to exploit the fur resources of North America drained by Hudson's Bay. At first the HBC traded and shipped from the bay, but when its Montreal-based competitors went inland and got ahead of them, the English company moved too. That was 1774, and in the following decades, fur forts rose along many rivers.

Alberta's oldest settlements, Fort Vermilion and Fort Chipewyan, trace to the fur trade. Both were built in 1788. Edmonton House and Fort Augustus went up in the 1790s, close to one another. Edmonton House was HBC; Fort Augustus belonged to the North West Company. This form of competition, placing a post where the competitor had one, repeated like a decimal. Upstream of Edmonton, the HBC built Acton House and the NWCo countered with Rocky Mountain House. A war between the companies intensified, became bloody; was financially ruinous to both. They amalgamated under the HBC name in 1821.

The new HBC didn't need two forts per location. Edmonton House (at Edmonton's present location) was kept along with its name, while Augustus was discarded. Upriver, Rocky Mountain House was chosen over Acton House. By this logic, the name of Alberta's capital might have been Augustus.

A photograph of Edmonton, taken in the year Alberta became a province, 1905, shows the newly built Legislature near the top of Edmonton's valley escarpment. The stone building gleams white and dominates the scene, but if you look closely you can see the tumbledown remains of Fort Edmonton below. The new and the eclipsed, one above the other.

In 1869 the HBC sold its domain to Canada. Ottawa seemed dumbfounded by its new possession, and did almost nothing with it. A tragic commerce moved into the vacuum. Doctored whisky was traded to First Nations people for their horses, buffalo hides and anything else the traders wanted. An economy violent and mad.

Finally shamed by an 1873 massacre of First Nations at a whisky fort in Canada's Cypress Hills, the prime minister, John A. Macdonald, stirred himself to create a mounted police force. The Mounties mustered in Manitoba and marched west in 1874. Their destination: a whisky fort called Whoop Up. The march was a gong show but when the Mounties arrived—or, more importantly, when they chose to stay the winter in an Oldman River fort called Macleod—their presence put the not very brave whisky men out of business.

Beyond Fort Macleod's palisade a village took shape, the first town of a new economy. You might call that economy "living off the government," because the money filtering down came from that source. William Gladstone, who lived at Fort Macleod, was a human bridge from fur trade times. At Fort Edmonton he'd built York boats. At Macleod he built whatever the Mountie economy needed: houses, stores, barracks, freight wagons.

My hometown of Pincher Creek was a Mountie outpost thirty miles west of Macleod. A ranch there supplied the Mounties with horses. Pincher was a pretty place near the Rockies, and some of the first Mounties to leave the force began ranching there. Fort Macleod also branched out to support a ranching economy. Also spawned by the Mounties was Calgary. Fort Calgary was built where the Elbow pours into the Bow River, in 1875.

The next stimulus to Alberta town building came from railways. The Canadian Pacific entered future-Alberta in 1882. Most everyone had expected it to be built along the old fur trade route from Winnipeg to Edmonton, then through the

Rockies by the Yellowhead Pass. Sandford Fleming had been hired to investigate routes, and the Yellowhead had been his recommendation. The trouble with that route was that it had too many people, ones with arguable rights to the land. Speculators were also buying there. So the owners of the CPR fooled everyone by choosing a route from Winnipeg through Regina and Calgary, and up the Bow River. There were hardly any towns and almost no settlers there. Hence, the slick dealing CPR and its insiders could be the ones who profited.

Medicine Hat and Calgary were dots on that line that became cities. But the CPR wand also touched down to create hamlets, such as Strathmore east of Calgary. Initially Strathmore was too dry to attract settlers. By 1905 the CPR had built an irrigation ditch using Bow River water, and Strathmore was picked up and moved 6.4 kilometres north to be on the ditch. The CPR built a demonstration farm there and served Strathmore vegetables in CPR dining cars. Another CPR profit scheme was Rocky Mountain tourism. Voilà! Banff and Lake Louise.

During 1890–91, the Calgary and Edmonton Railway Co. built a south–north line. Their plan was to build it and then lease it to the CPR. The row of new towns included Airdrie, Crossfield, Olds, Innisfail, Red Deer, Lacombe, Ponoka, Wetaskiwin and Leduc.

This was just the beginning of Alberta's railway saga. Next, the Grand Trunk Pacific Railway did what Sandford Fleming had suggested. Between 1905 and 1914 it laid rail from Winnipeg to Edmonton and over Yellowhead Pass. A bankruptcy later, the line belonged to Canadian National Railway.

One CNR town between Edmonton and the Saskatchewan boundary was Vegreville, a French Canadian village named for an Oblate missionary. A wave of immigrants from Eastern Europe turned it into the largest town of the farming district known as the "Ukrainian bloc."

More railways spidered out. The Edmonton, Dunvegan and British Columbia Railway headed northwest into the Peace River country. The Alberta and Great Waterways Railway went northeast, with a station at the early fur trade post and Catholic mission of Lac La Biche. It ended, prematurely, at the oil sands.

The way railway companies orchestrated towns along their right-of-ways was anything but serendipitous. Historian Donald Wetherell has written the bible on this: *Town Life: Main Street and the Evolution of Small Town Alberta, 1880–1947*. To encourage rail lines, government gave the companies cash and land. The companies determined where everything would be. Sidings every six to ten miles. Stations every ten to twenty miles. The railway company both chose

the townsites and surveyed and sold the lots. They sold the land around the towns to farmers. In this way, railway companies produced what Wetherell calls "a hierarchical pattern of towns." A siding's prospects topped out at hamlet. To be a town, you had to have a station. To help towns into existence, the companies sold cheap lots for hospitals, hotels and schools.

At the same time that the railway companies were installing future-Alberta's basic architecture, another propulsive force was creating a less engineered brand of settlement. The nascent Alberta coal industry was making coal towns. By then, the 20th century, it was well understood that Alberta was thickly underlain by coal. As usual, Europeans were learning what First Nations already knew. The Blackfoot name for a section of the Oldman River was "Place of Black Rocks." Early traders translated that as "Coal Banks," and a US Civil War vet, Nicholas Sheran, dug a one-man drift mine there in the 1870s, making him Alberta's first commercial coal miner. This spot would in time become Lethbridge.

In 1884, government geological surveyor Joseph Tyrrell went to the Red Deer River valley and declared it a vast coal resource. According to legend, Tyrrell fell over an Albertosaurus skull the same day.

In the mountain part of the Bow Valley, there were two coal mines running by 1888, conveniently beside the CPR main line. From this origin, the town of Canmore would develop.

In the early 1890s a narrow-gauge railway connected Lethbridge coal to CPR's mainline at Dunmore near Medicine Hat. A series of business manoeuvres later, CPR controlled the rights to build a railway to the much larger coal resource in the Crowsnest Pass. By 1897 CPR owned the Crowsnest Pass Railway.

Coal mining was labour intensive and each time a Pass mine was dug, it needed a town. A string of these popped up: Lundbreck, Burmis, Bellevue, Hillcrest, Frank, Blairmore, Coleman.

There was also Lille, high above what became the Frank Slide. A short rail spur full of trestles served Lille. The town had a school, hospital and hotel. Lille's remains are a hikers' destination now, and the hotel's ornate bar lives just outside the mountains in Lundbreck's tavern.

Crowsnest Pass towns may well be the most fascinating and tragic of all Alberta settlements. Mining is dangerous enough, but early in the Pass's coal-mining history, tragedy came not from below but from above. On April 29, 1903, part of Turtle Mountain fell on top of the town of Frank. When you look at that valley of broken stone, it's hard to believe anyone survived, but houses and people close beside

the path of the Frank Slide did. As many as 90 people did not. The whole thing happened in 90 seconds.

On June 19, 1914, the Hillcrest mine disaster killed 189 men underground, more than half the workforce. Ninety women were widowed, 250 children left fatherless.

Crowsnest miners came from all over the mining world and brought with them the union movement. Strikes were frequent and the strikebreaking vicious. My favourite story is how Blairmore responded to a failed eight-month strike in 1933. The town elected a "Red" town council and renamed their main street Tim Buck Boulevard after the jailed leader of Canada's Communist Party.

Commercial development of the vast Red Deer River coal deposit began in 1911. Over time there would be 139 registered mines in the valley. The big town associated with these mines was Drumheller, named for Samuel Drumheller, who bought the land for the town from a local homesteader and sold it to the railway company. Hamlets also popped up close to the mines. To get an idea of how many hamlets there were, Drumheller eventually absorbed thirteen of them: Rosedale Station, Bankview, East Coulee, Midland, Nacmine and Newcastle, to name a few.

The same year loaded coal cars started leaving Drumheller, the Grand Trunk Pacific Railway began harvesting quality steam coal in the foothills east of Jasper. Among the "Coal Branch" towns were Coalspur, Embarras, Robb, Cadomin and Luscar.

Surprise! Alberta also has oil towns. These had much in common with coal towns but were more transient. Early residents of the Turner Valley wet gas boom skid-mounted their houses. When drilling was done in one place and wells were spudding in another, you could hook a team to your home and skid it over. There was plenty of irony in Turner Valley humour. During the Great Depression, the valley's gas boom failed. But in 1936 a well drilled to a deeper horizon shockingly found oil. The boom was back on. Longview, a village named for homesteaders, became an overnight oil city, and locals nicknamed it Little New York. Up the hill was another sudden town, Little Chicago.

After Turner Valley, Alberta's oil explorers experienced a decade-long slump. They batted exactly zero. In 1947, Imperial went after a different kind of structure near Edmonton and hit a big one. After this Leduc strike, a host of companies went after similar geological targets and Alberta was suddenly awash in oil—also prosperous like never before. Any Alberta town that appeared or experienced rapid growth after 1947 was either an oil town or a bedroom community.

After all this talk of what sparked Alberta towns to life, I'll switch to something more Malthusian; that is, to what made Alberta towns shrink or disappear. Back near the beginning, a popular cause of decease was to have a railway pass you by. Grouard, Alberta, was a dramatic case. In the first years of the Peace River homestead boom, Grouard, on the west end of Lesser Slave Lake, was the frontier's gateway. Homesteaders loaded their gear onto a steamboat at Lesser Slave's east end, floated for a hundred kilometres, and got off at Grouard before proceeding northwest. Grouard's prospects were so great that surveyors designed streets and lots well back into the forest. They were anticipating a city. Then the Edmonton, Dunvegan and British Columbia Railway came—and missed Grouard by twelve miles.

Other towns the railway missed were close enough to move to where it was. I am rather proud that my hometown of Pincher Creek did not move an inch when the Crowsnest Pass Railway snubbed it by 4.3 kilometres. Pincher calmly spawned a sub-town, Pincher Station, where its grain elevators and auction mart would be.

Another form of demise was the resource town that no longer had its resource (e.g., a coal town without coal). A formula for a ghost town, it would seem, but that depended on the town and its surroundings. Drumheller annexed valley hamlets not because they were dead but because they were

alive. Given an attractive landscape, lots of dying towns are kept going by people looking for a different lifestyle. Pleasantly democratic, these people can be rich or poor.

A separate version of this, and a much more widespread problem, affects towns that were breathed to life in farming communities. When people became able to drive a hundred kilometres per hour, rather than ten to twenty miles a day in a horse-drawn wagon, towns didn't have to be so close together. A lot of towns lost out to this arithmetic.

"What one era needs the next era may not want" is a slogan I came up with to encompass another class of wilt. When Alberta's oil and gas came on strong, the new economy destroyed more towns than it built. King Coal was deposed, especially after the province built a gas distribution pipeline that served even individual farms. Alberta's coal-fired electricity business is taking a hit right now (which I admit I'm in favour of) to reduce carbon and hopefully slow down climate change.

Another destroyer of small agricultural towns has been the demise of small farms. "The small farmer can't make a go of it anymore" has become a mantra. Some of those who say it own industrial farms with rows of combines and tractors as big as houses. Of all the changes I have seen in rural Alberta, this one saddens me most. What becomes of land no one lives on? What becomes of small towns built to support

small farmers? I am not sure lifestyle-choice can perform the level of rescue needed.

Rather than end on a glum note, I'll speak finally of one of Alberta's durable small towns: Pincher Creek. Pincher's graph has risen and fallen many times, but the place always seems to have a population of 3,000. To reprise, it has been a Mountie town, a ranching town, a homesteader town and an oil and gas town. When the oil and gas industry swaggered in, things got very slick for a time. Nowadays the gas plants are all but robots and the reservoirs have dwindled. Of late you might say the town's economy is a retirement one, as the farmers got old, sold out and moved to town. That's not the extent of it; there still are farmers and ranchers of the most resilient kind. Also there's a BC sales tax economy: cross-border shoppers loading up in Pincher Creek stores. Pincher is also a wind town, having a found a way to market its bane. The surrounding ridges are lined with wind turbines. On account of ingenuity—and, yes, luck—Pincher has always been able to hop to a new lily pad.

What comes next for rural Alberta I cannot know, but I do know what I want to see. That would be a new generation coming to the land, possessed of the highest and newest and lowest and oldest technologies. Like the homesteaders of old, they would be in it for the long haul, not a quick killing, and Alberta small towns would appear or revive to support them, as Alberta towns have always existed to do.

OUR TOWNS
BY ROSEMARY GRIEBEL

Wherever we looked the land would hold us up.
　　　　　　　　　　　—William Stafford

A creased name on the map, a place you pass by
on a highway going somewhere else:
Byemoor, Castor, Huxley, Viking…
You turn into town at the closed gas station,
drive slow down the main street, empty
and exposed as an interrupted dream.
There's the Cosmopolitan Hotel sun-bleached
and silent, and the last grain elevator standing.
There's the Coca Cola sign waltzing
in the wind, and a Legion Hall with four wars'
worth of stories within. You think
nothing happens here. Look again.

Here is where a traveller came
all the way from China and opened
a cafe that served steaming bowls
of soup and chow mein while winter winds
billowed the plastic sheeted windows.
Here teenagers swam in the creek to dampen the spark
and heat of their electric bodies. Here parents learned
the language of the land, the ways of sandhill cranes
reeling above huddled homes, announcing spring.
In September, the smell of crab apples, grain dust,
and boiled-down potatoes. Combines worried the fields
of a too thin harvest under a blood red moon. Mornings,
the school bus travelled a black back road to homes
where children awkward and full of grace
waited at the end of the lane.

Look back. The children left this place
as soon as they could. Hotels boarded up,
drive-in theatres became fields filled with fox tail
that conducts the wind. Trees still extend their playful arms
beside a house where a family once stood
hearts cracked open with the unbearable beauty
of life. Nothing dies as slowly as a town.
The graveyard documents a library of lives,
their names catalogued in granite.
Churches boarded up, the Lord gone
from every town we called home and left.
But I have loved these small towns, and there are times

I grieve for what they longed to be.
World's Wheat King Capital now a suburb
that commuters rush from towards
a skyline of towers perpetually lit.

These towns were the way the land held us,
and that's the way I want to be held; to know
the land will always be with me no matter how far
I travel across a map of places once wild
with hope and promise: Carbon, Rimbey, Chin, Empress…
Here are the images that recall streets washed with rain,
the friendly face of Clara's Variety or Ray's General Store.
The sweet ache for everything lost or gone.

PHOTOGRAPHS
BY GEORGE WEBBER

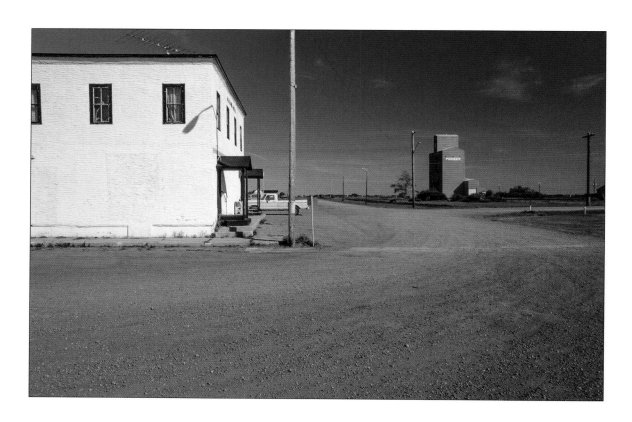

Strome, Alberta, 1986

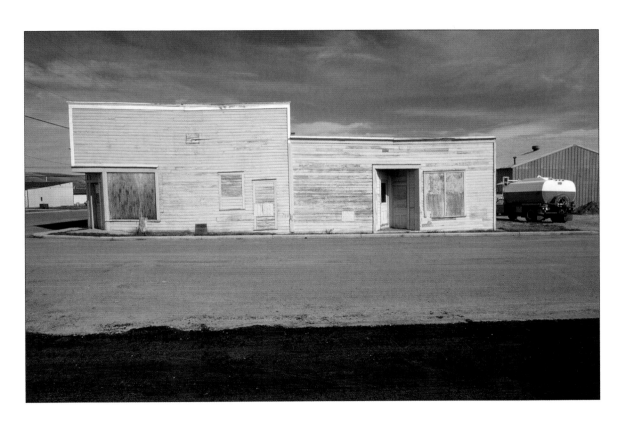

Carbon, Alberta, 1986

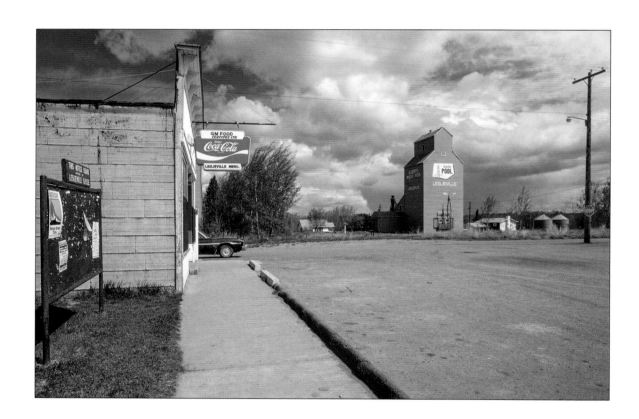

Leslieville, Alberta, 1984

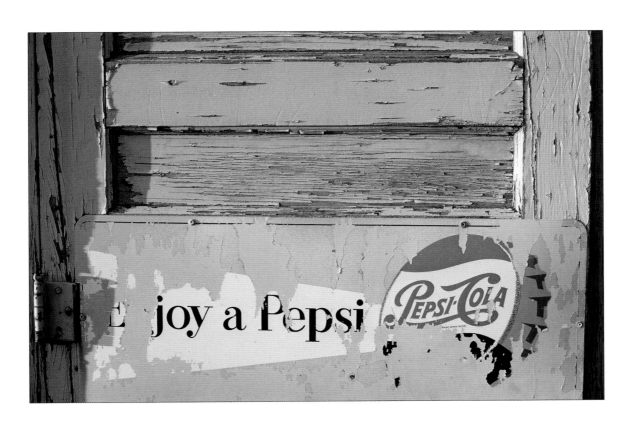

Lethbridge, Alberta, 1983

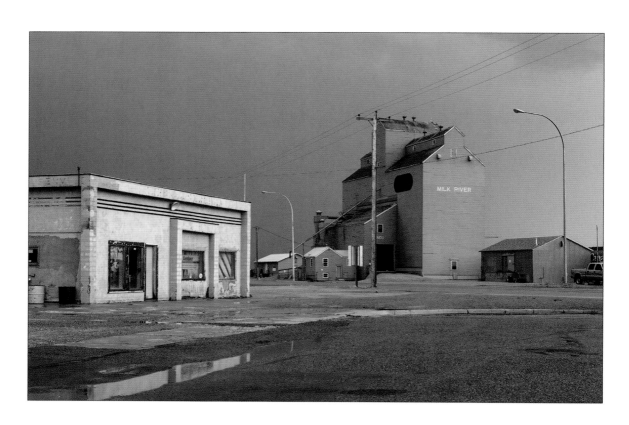

Milk River, Alberta, 2008

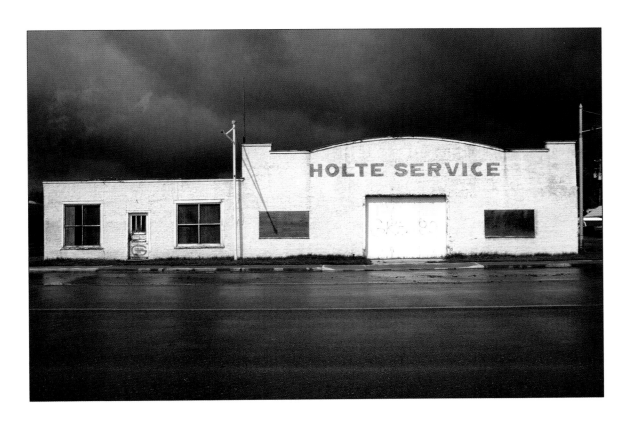

Big Valley, Alberta, 1987

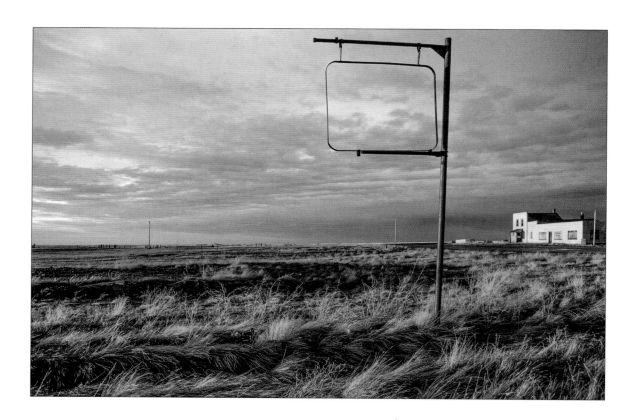

Skiff, Alberta, 1995

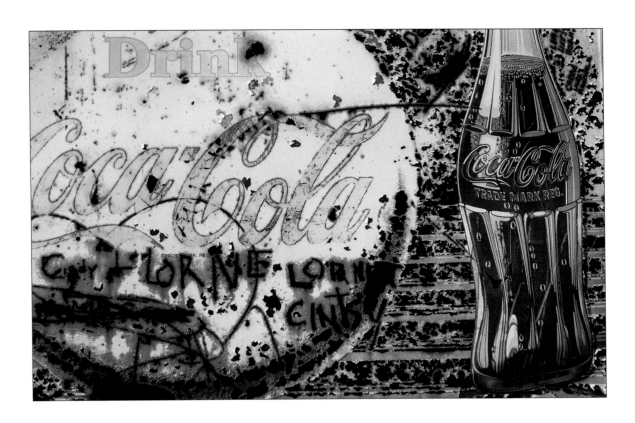

Craigmyle, Alberta, 1987

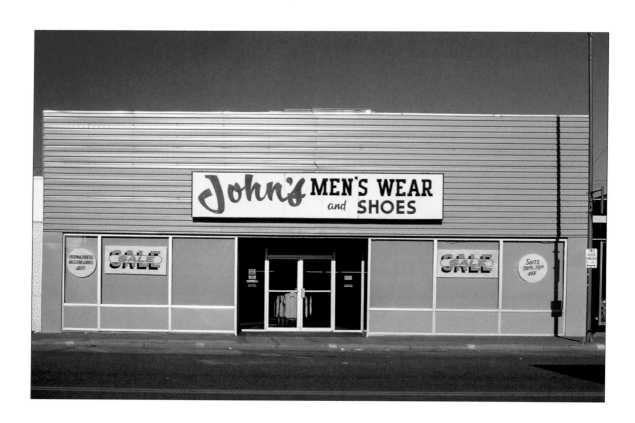

Stettler, Alberta, 1981

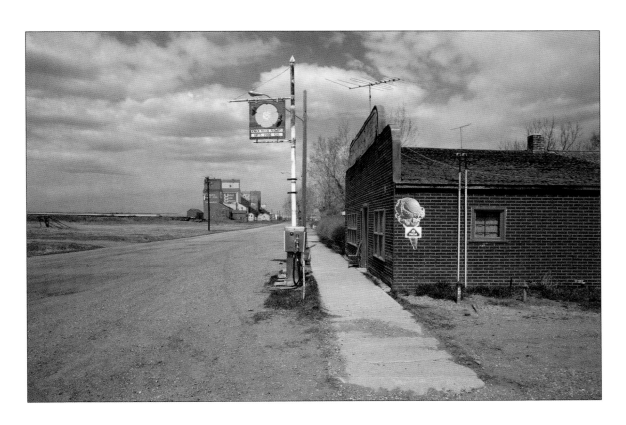

Carmangay, Alberta, 1992

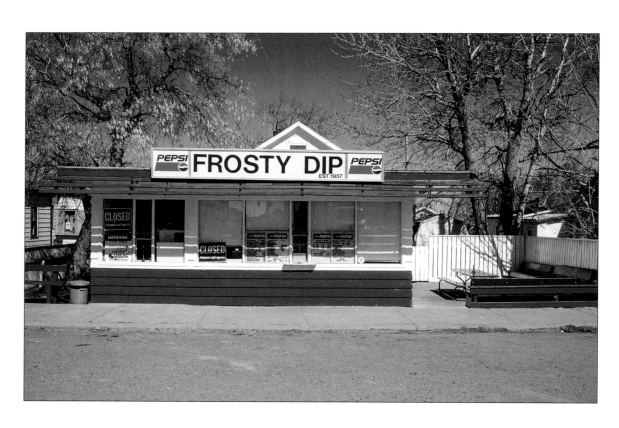

Picture Butte, Alberta, 2003

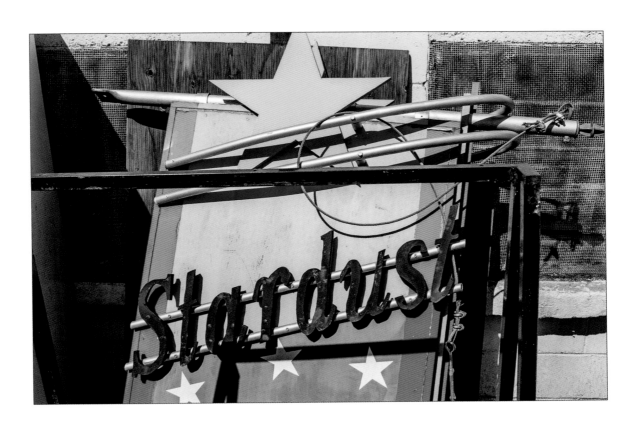

Medicine Hat, Alberta, 2004

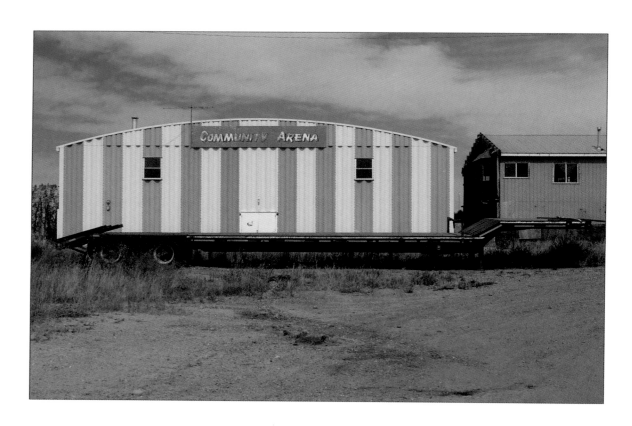

Burdett, Alberta, 2008

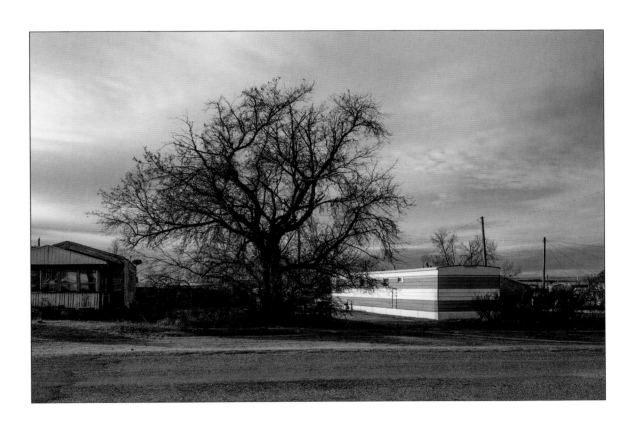

Swalwell, Alberta, 2010

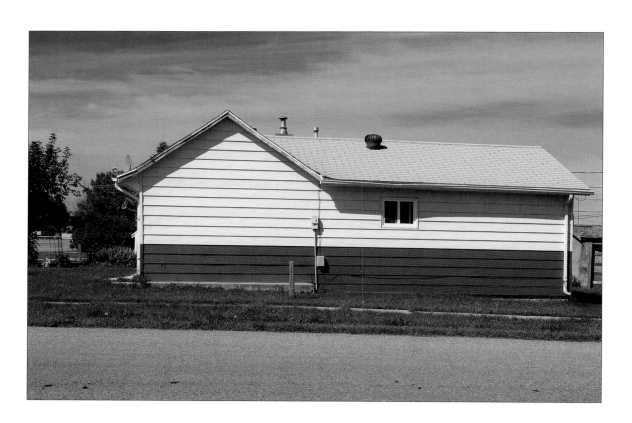

Shaughnessy, Alberta, 2009

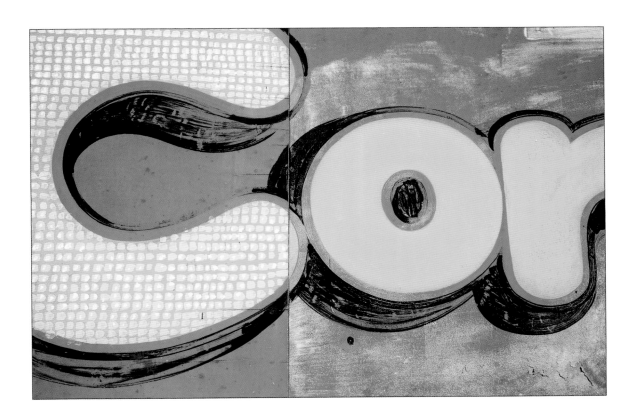

Taber, Alberta, 2012

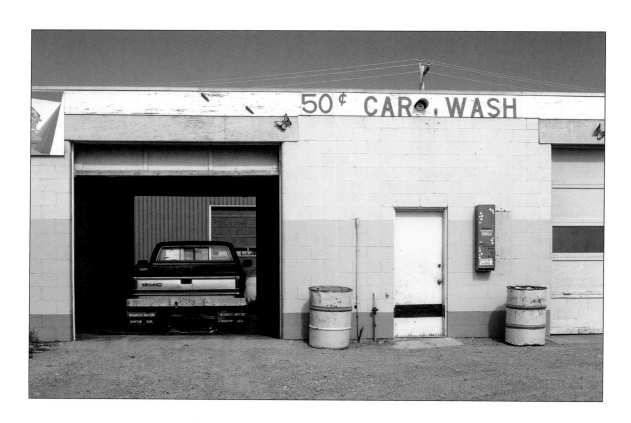

Nanton, Alberta, 1985

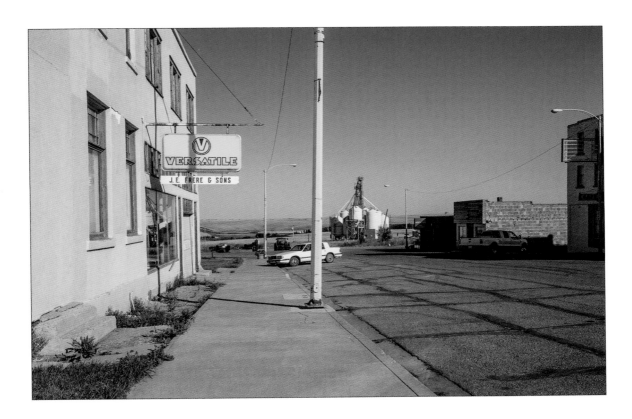

Trochu, Alberta, 2011

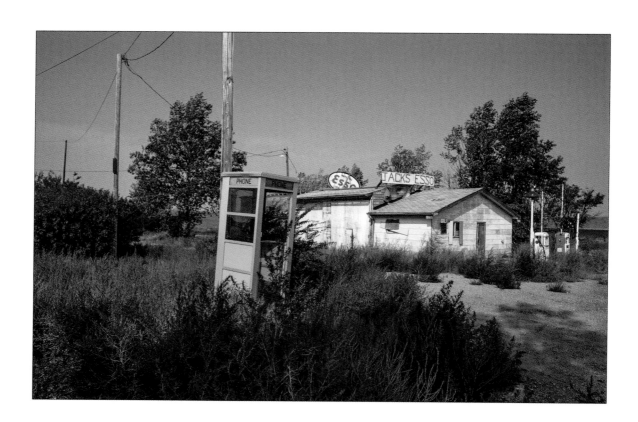

Sibbald, Alberta, 1986

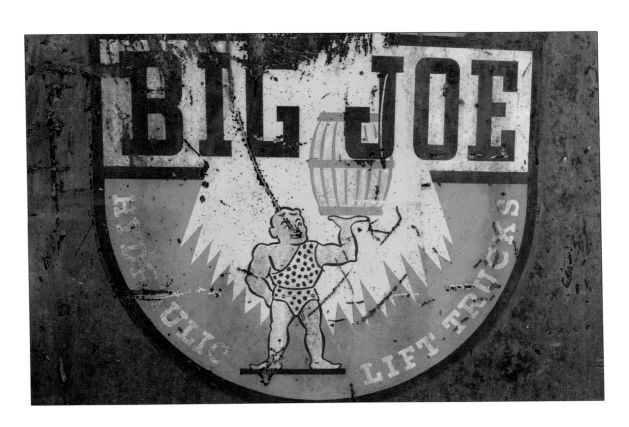

Camrose, Alberta, 2011

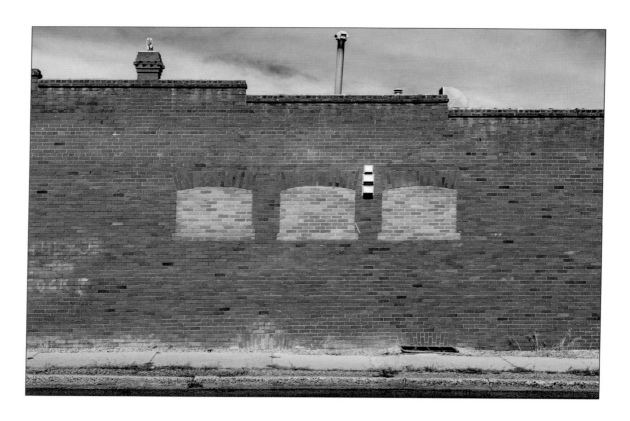

Medicine Hat, Alberta, 2008

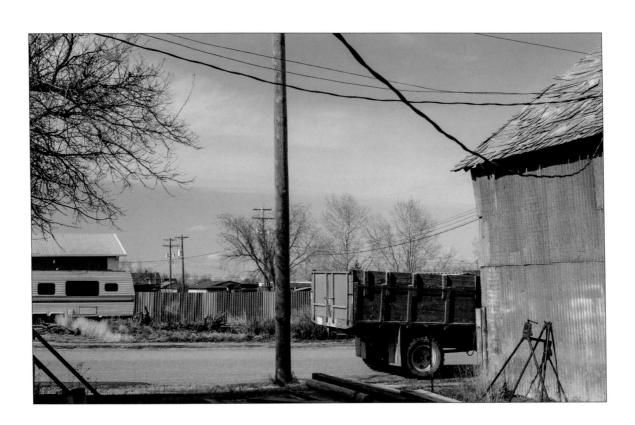

Hussar, Alberta, 2008

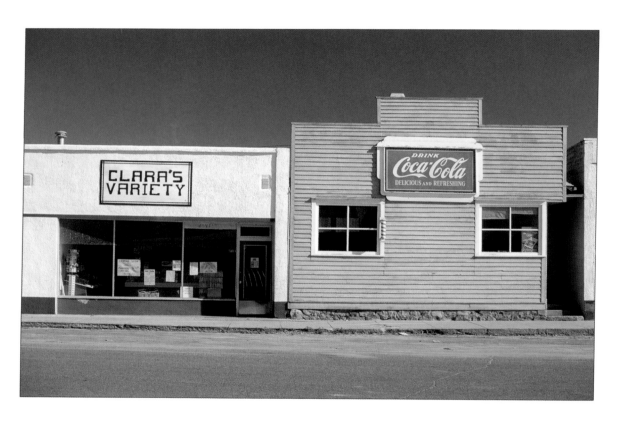

Delburne, Alberta, 1981

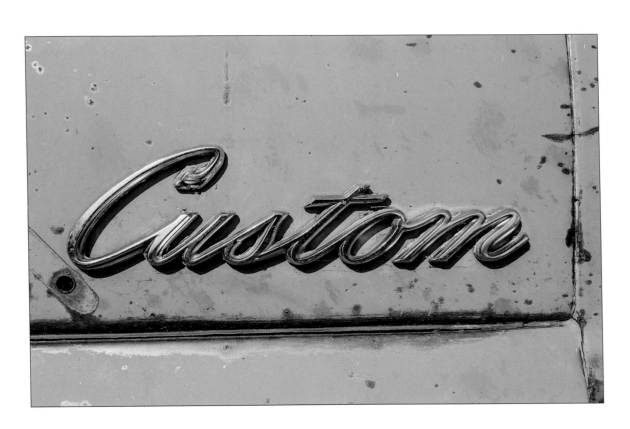

Wrentham, Alberta, 2012

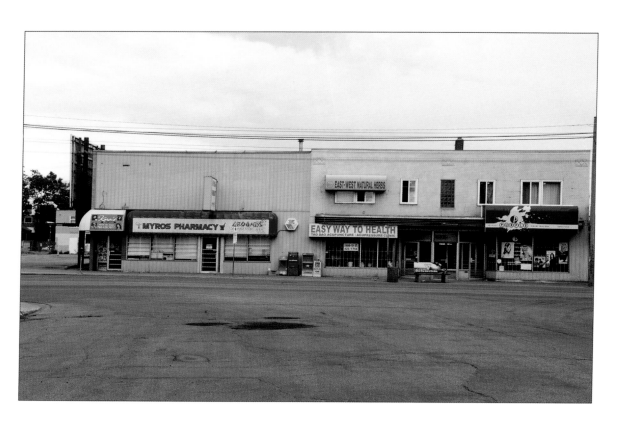

Edmonton, Alberta, 2008

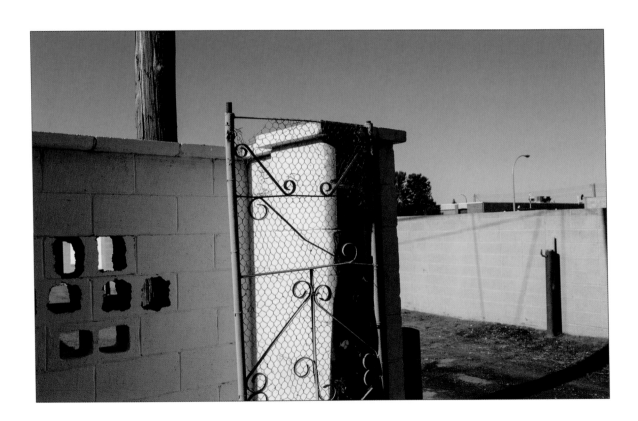

Lethbridge, Alberta, 2011

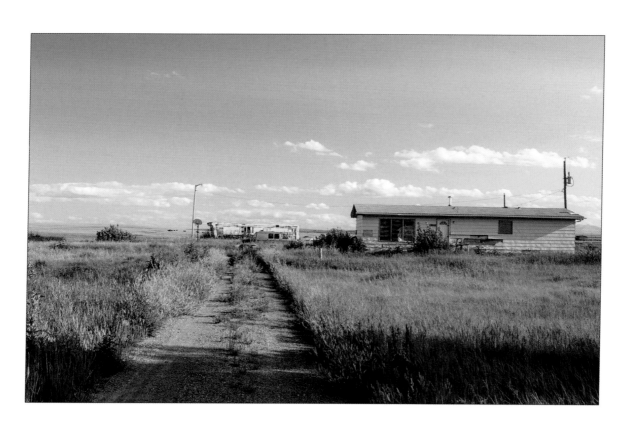

Levern, Alberta, 2009

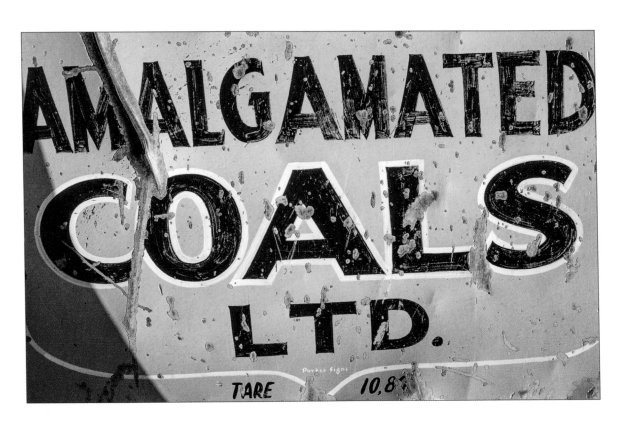

East Coulee, Alberta, 1984

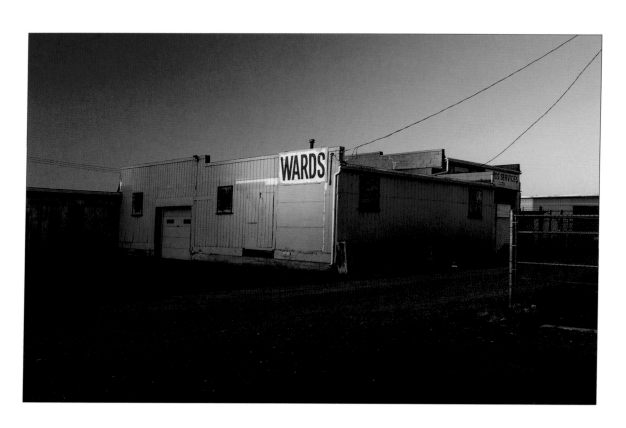

Lethbridge, Alberta, 2005

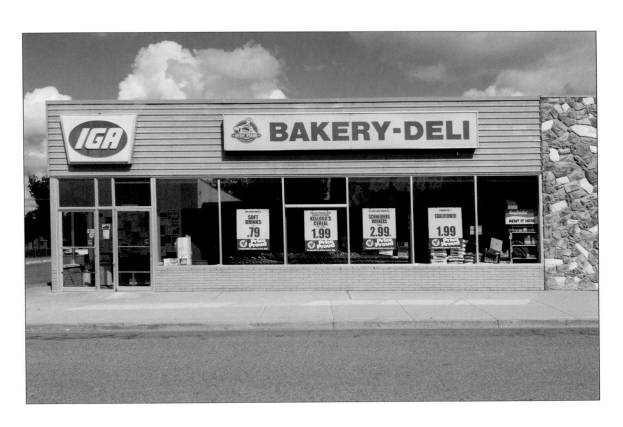

Bow Island, Alberta, 2004

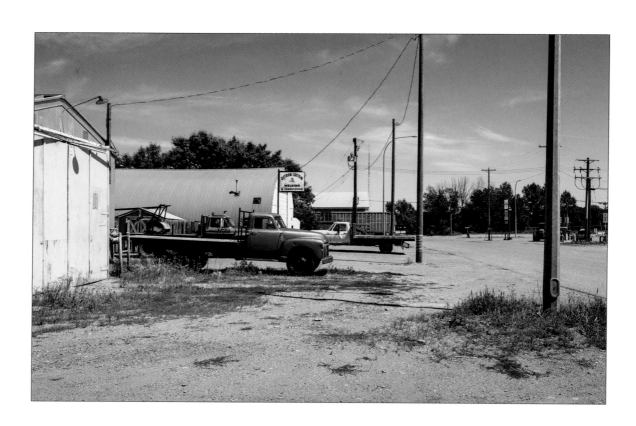

Nanton, Alberta, 2011

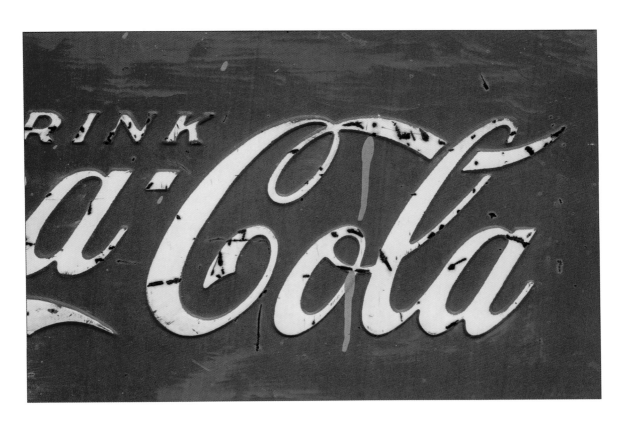

Endiang, Alberta, 2011

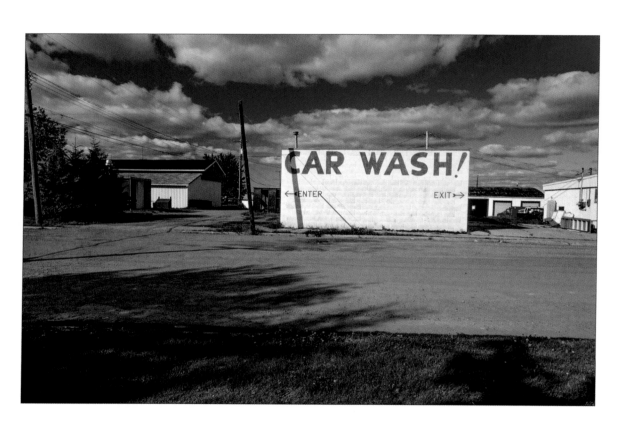

Mayerthorpe, Alberta, 1991

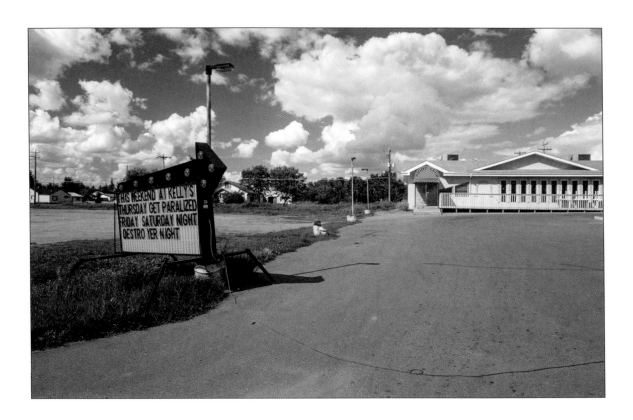

Wainwright, Alberta, 1993

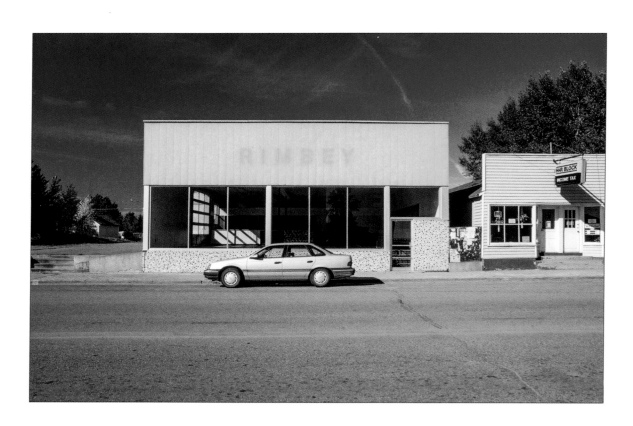

Rimbey, Alberta, 1991

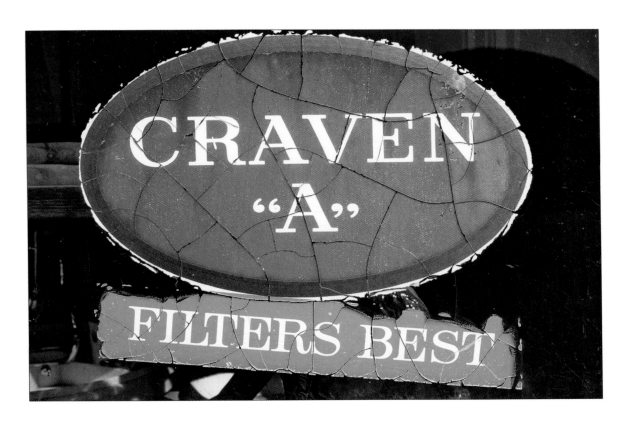

Delia, Alberta, 1986

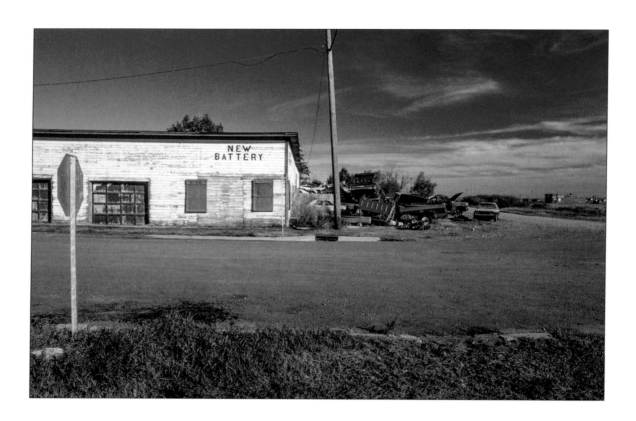

Cluny, Alberta, 1995

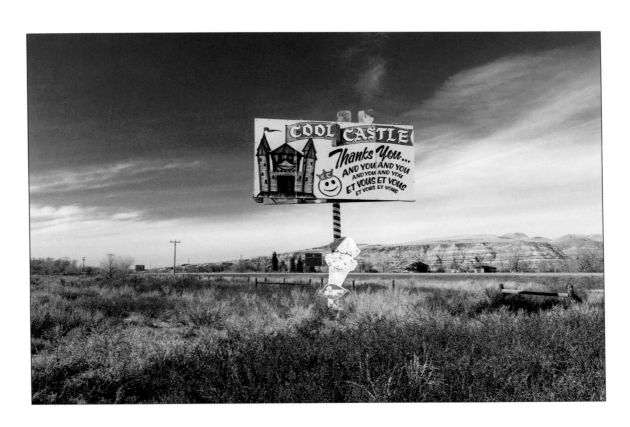

Near Rosedale, Alberta, 2010

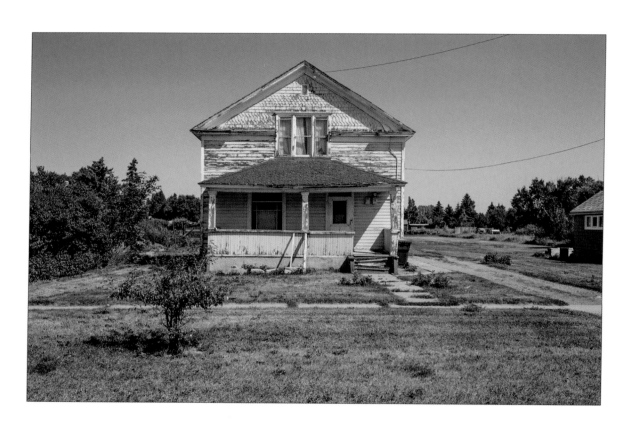

Raymond, Alberta, 2012

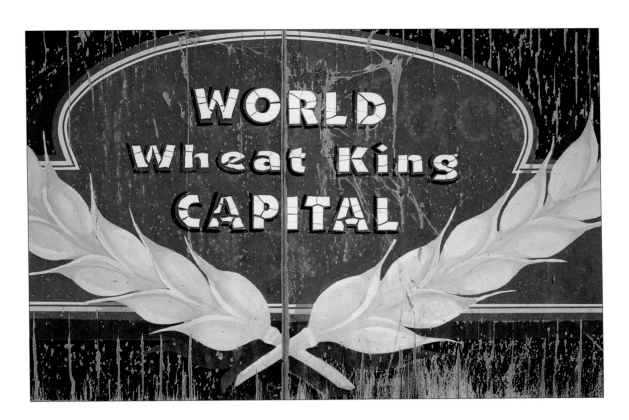

Beiseker, Alberta, 2012

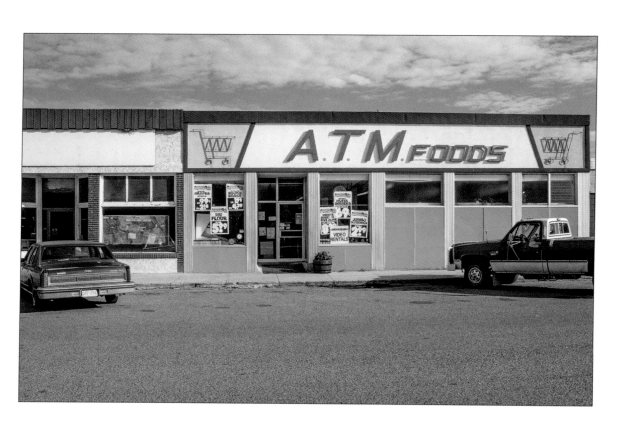

Nanton, Alberta, 1989

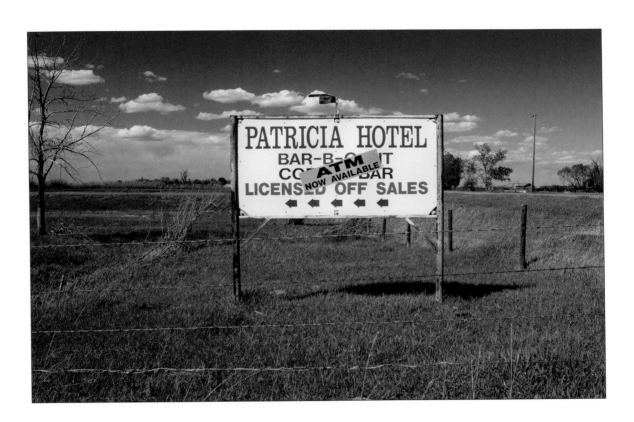

Patricia, Alberta, 2010

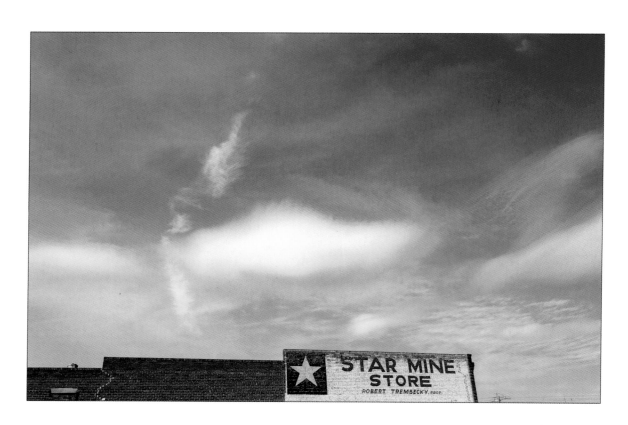

Drumheller, Alberta, 2012

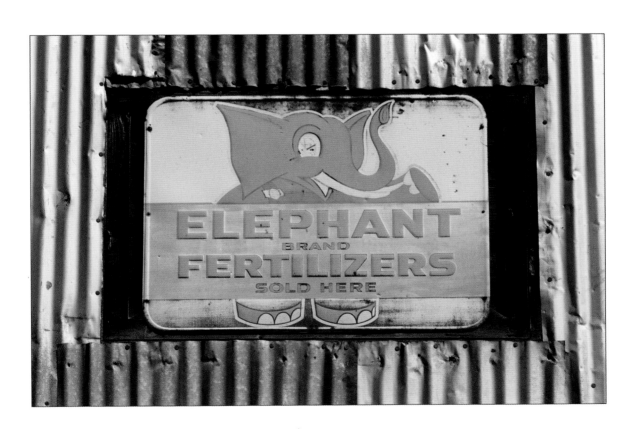

Kitscoty, Alberta, 1987

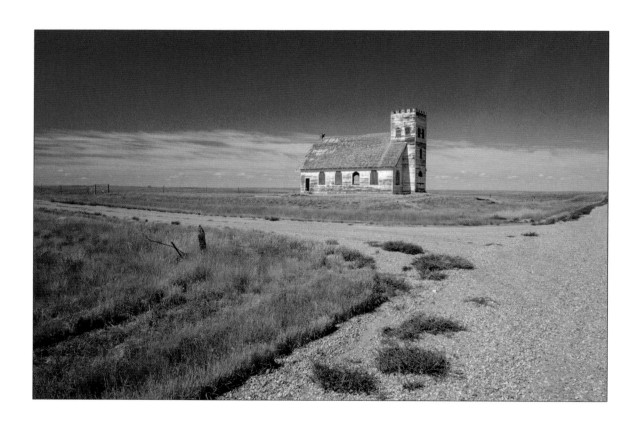

Retlaw, Alberta, 1985

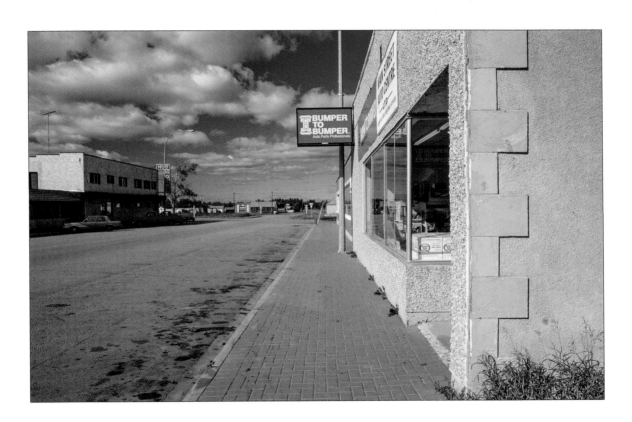

Mayerthorpe, Alberta, 1991

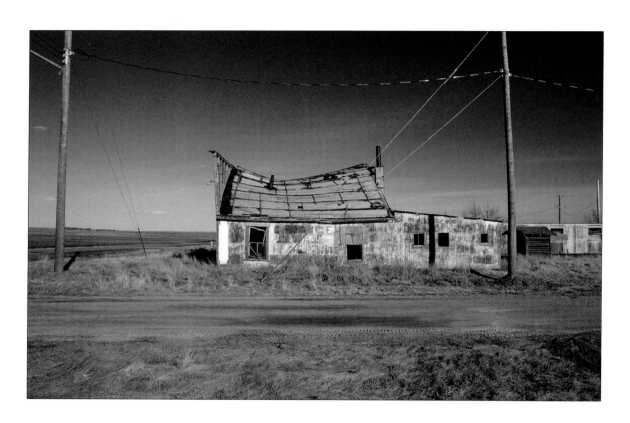

Spring Coulee, Alberta, 1988

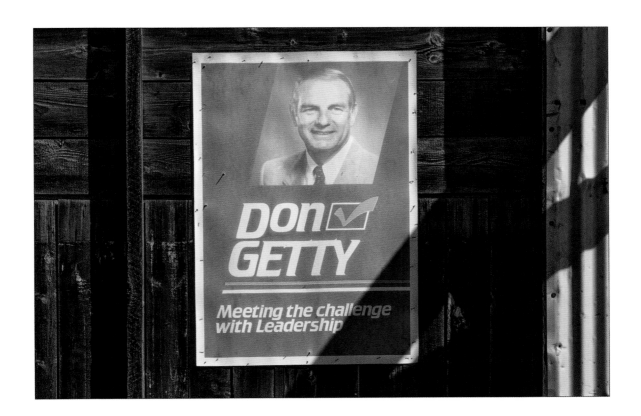

Kitscoty, Alberta, 1987

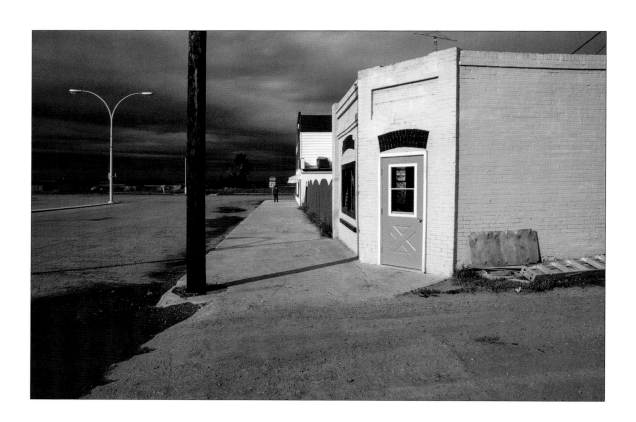

Lougheed, Alberta, 1987

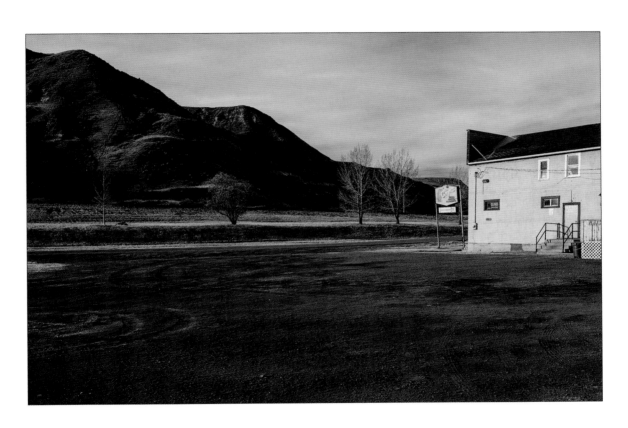

Nacmine, Alberta, 2010

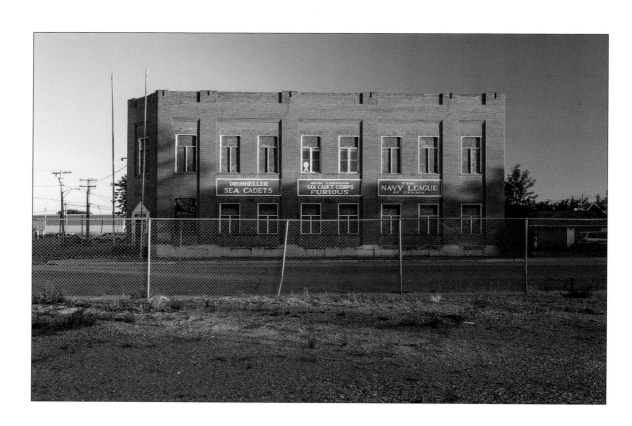

Drumheller, Alberta, 2011

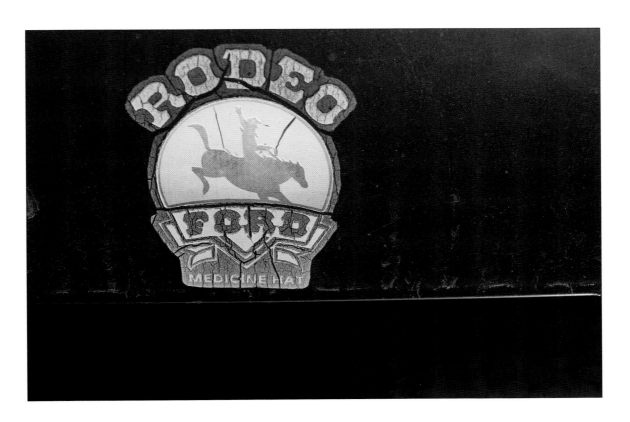

Chin, Alberta, 2012

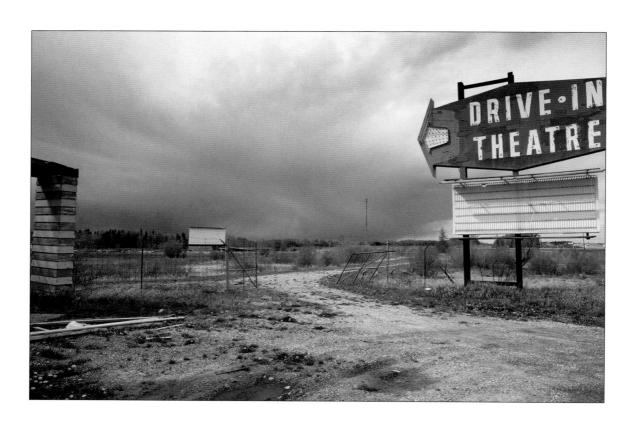

Red Deer, Alberta, 1984

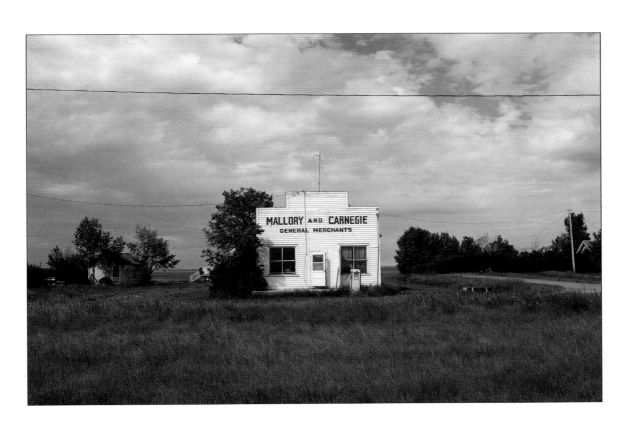

Kircaldy, Alberta, 2005

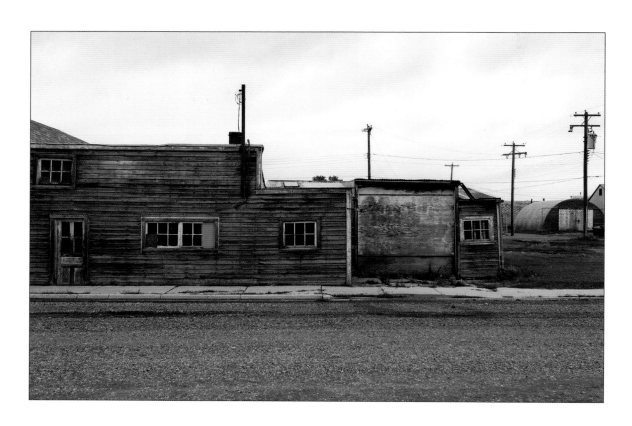

Blackie, Alberta, 2004

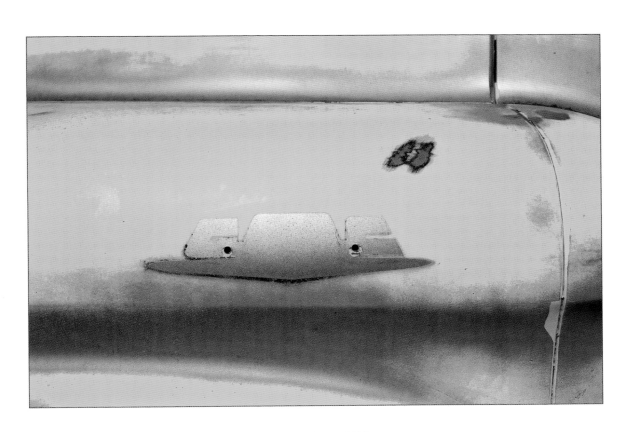

Raymond, Alberta, 2012

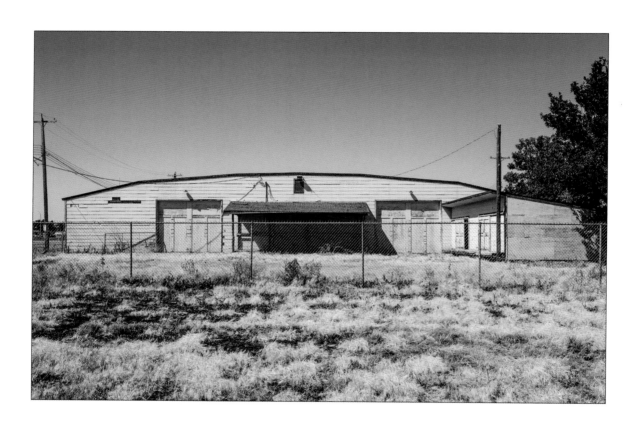

Taber, Alberta, 2012

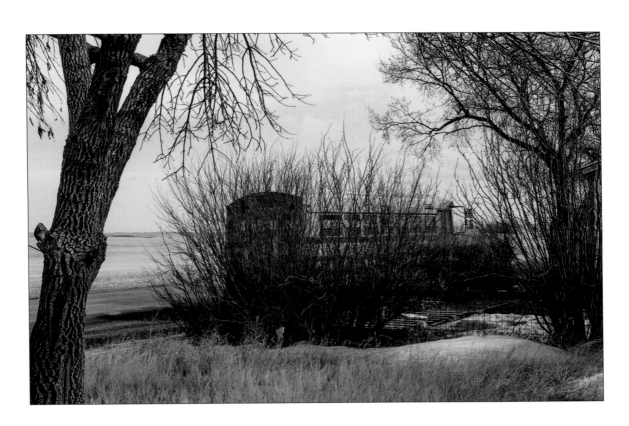

Hussar, Alberta, 2008

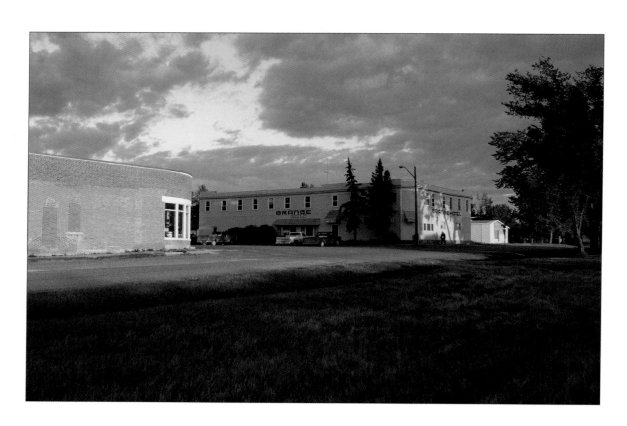

Carmangay, Alberta, 2005

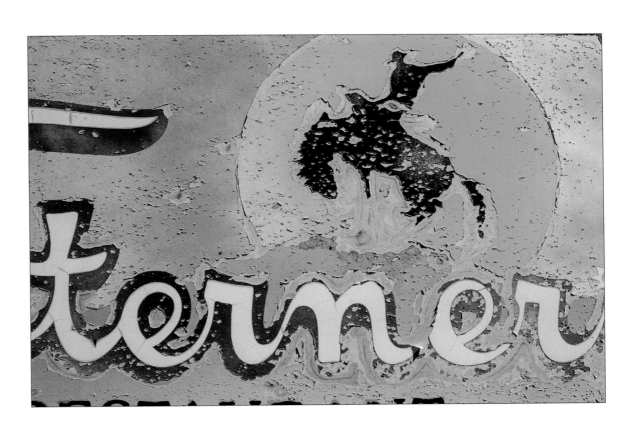

Fort Macleod, Alberta, 2010

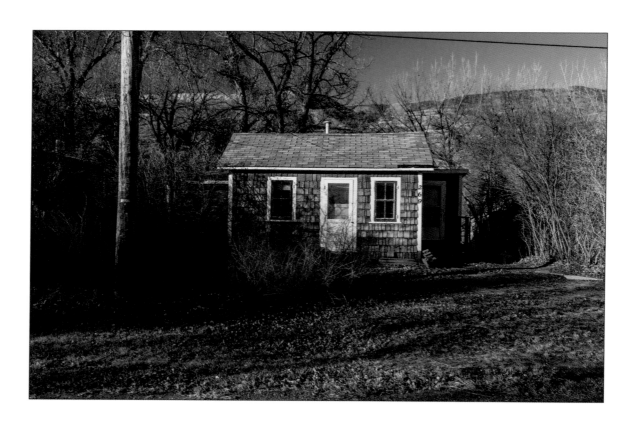

East Coulee, Alberta, 2010

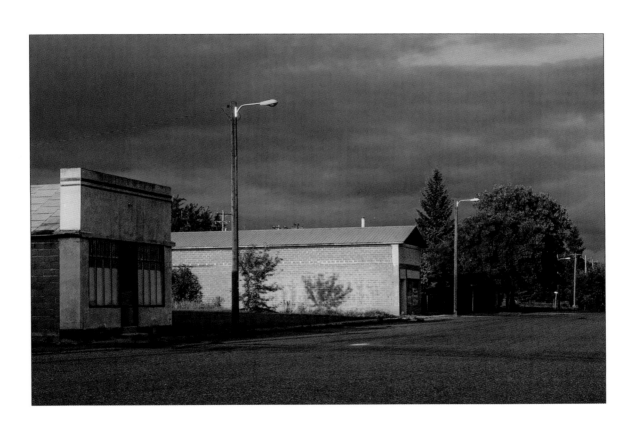

Myrnam, Alberta, 2007

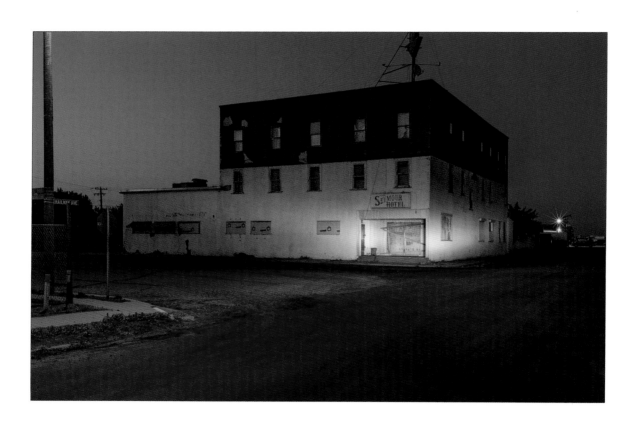

Hanna, Alberta, 2012

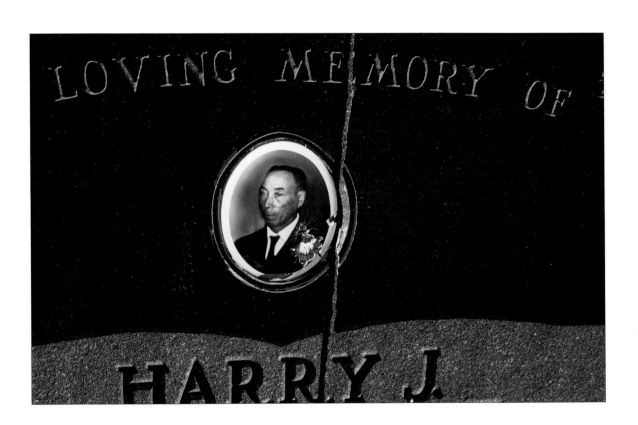

Standoff, Alberta, 2009

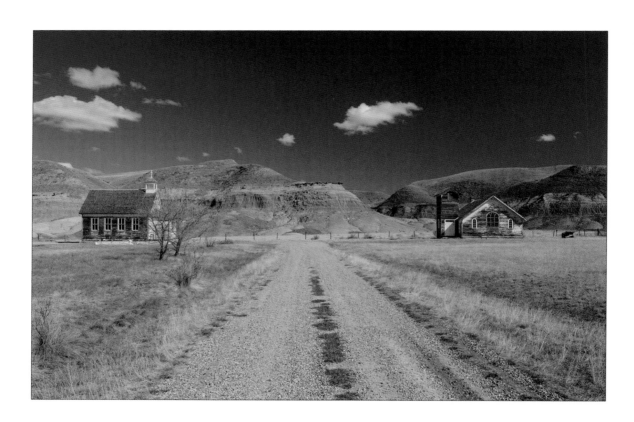

Dorothy, Alberta, 2010

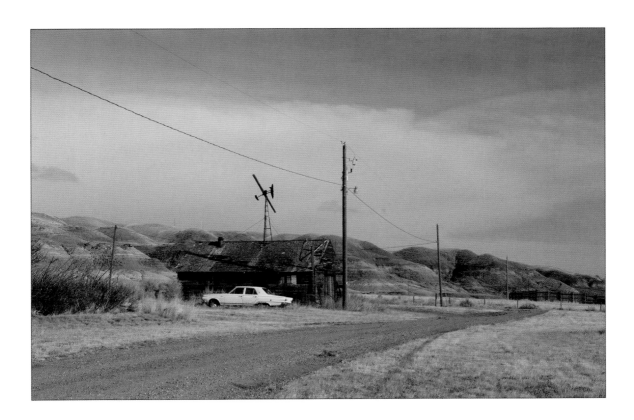

Dorothy, Alberta, 2008

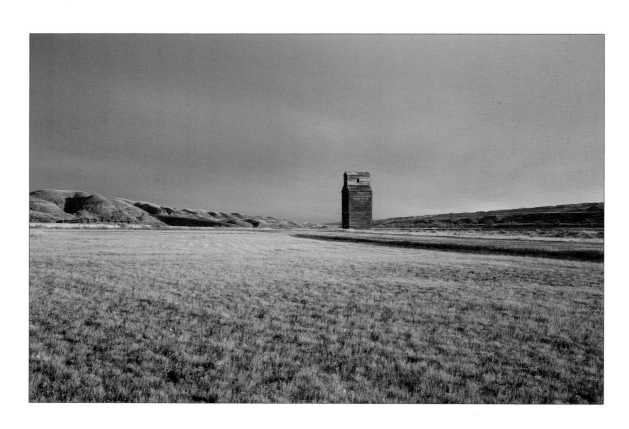

Dorothy, Alberta, 2010

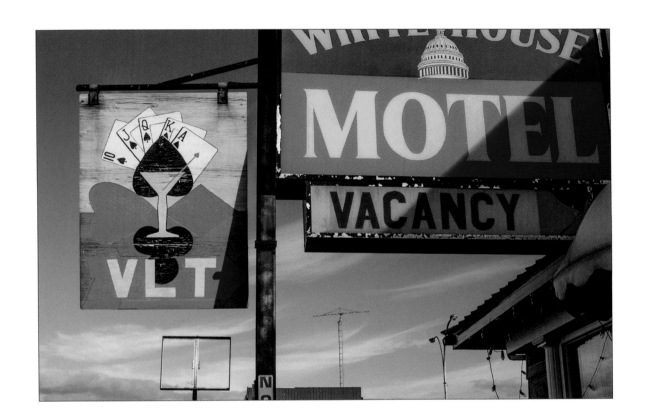

Lougheed, Alberta, 2007

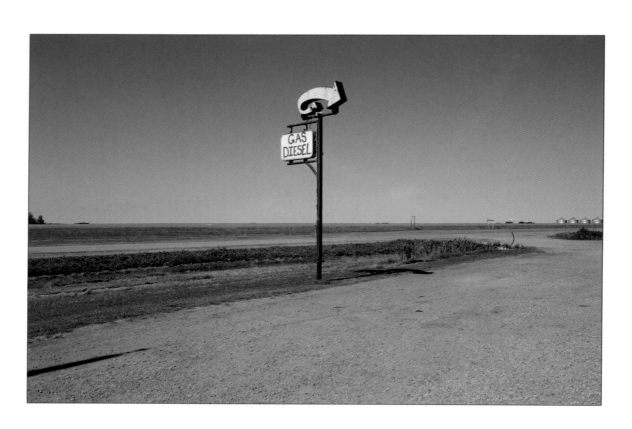

New Norway, Alberta, 2011

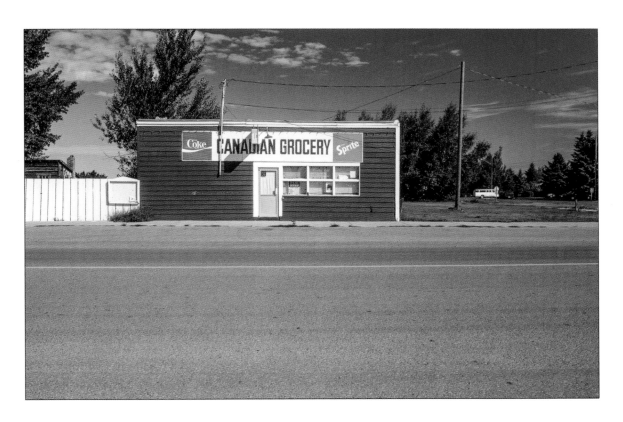

Stirling, Alberta, 1999

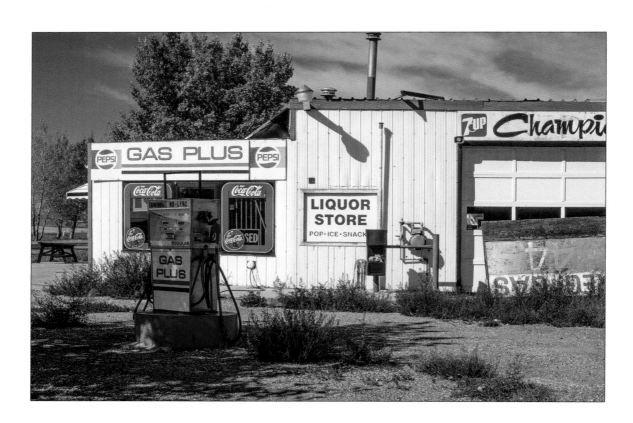

Champion, Alberta, 2001

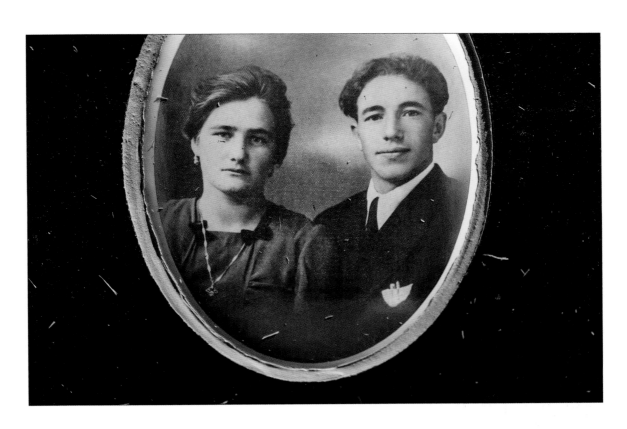

Vulcan, Alberta, 2012

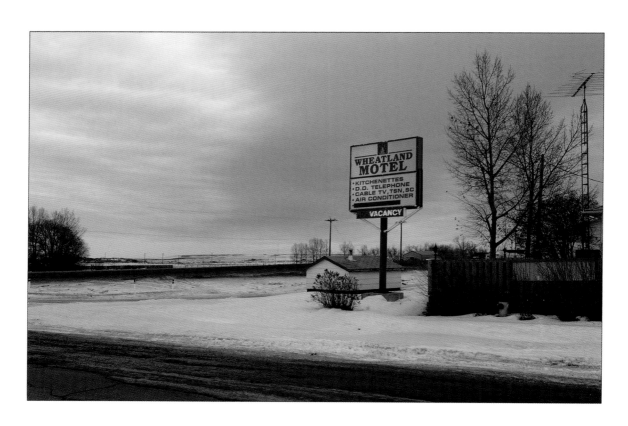

Vulcan, Alberta, 2003

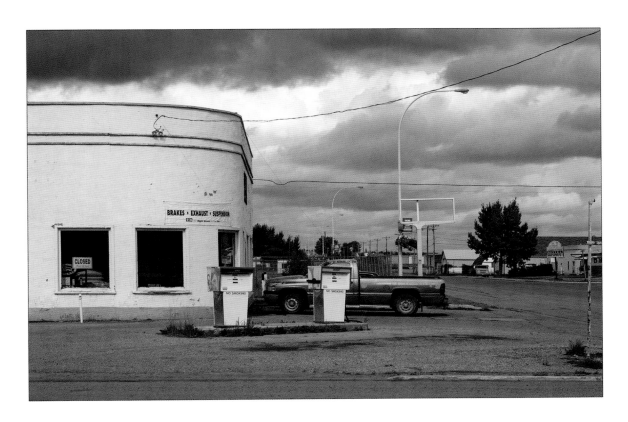

Viking, Alberta, 2007

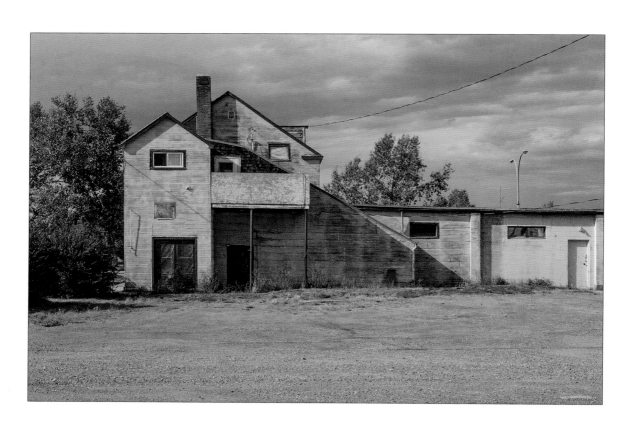

Warner, Alberta, 2008

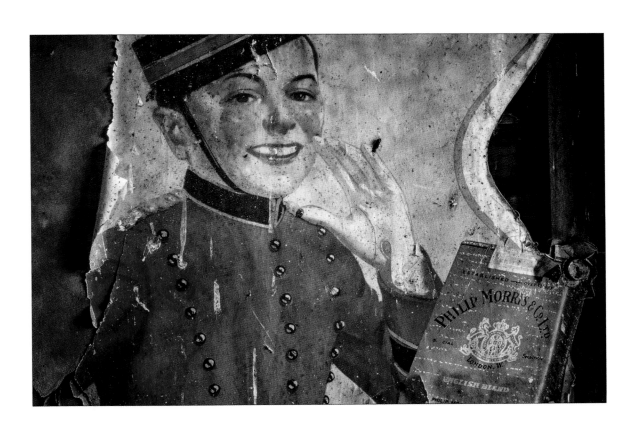

New Dayton, Alberta, 1995

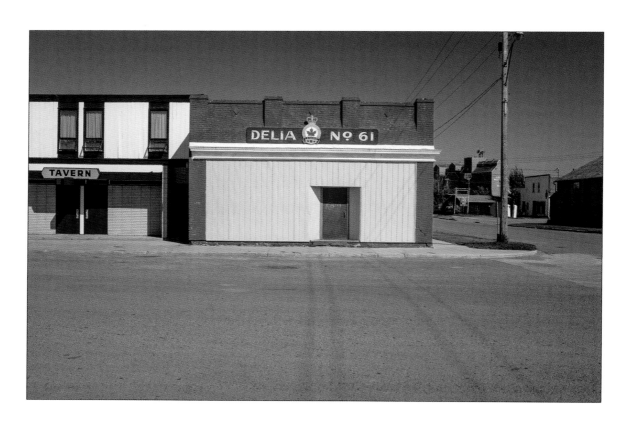

Delia, Alberta, 1986

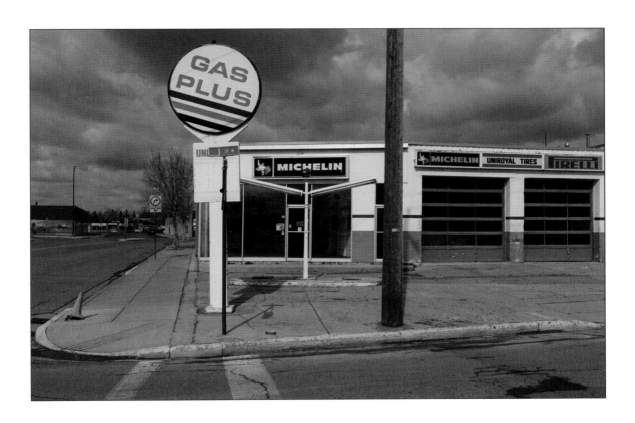

Drumheller, Alberta, 2010

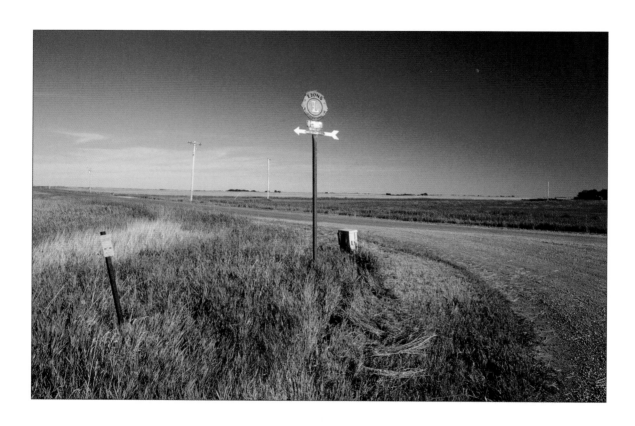

Keoma, Alberta, 1995

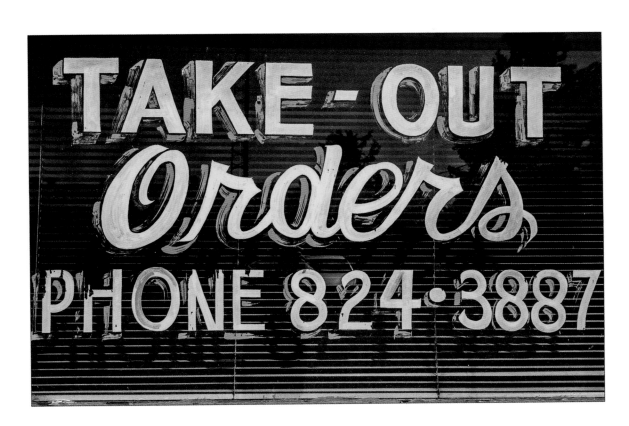

Nobleford, Alberta, 2012

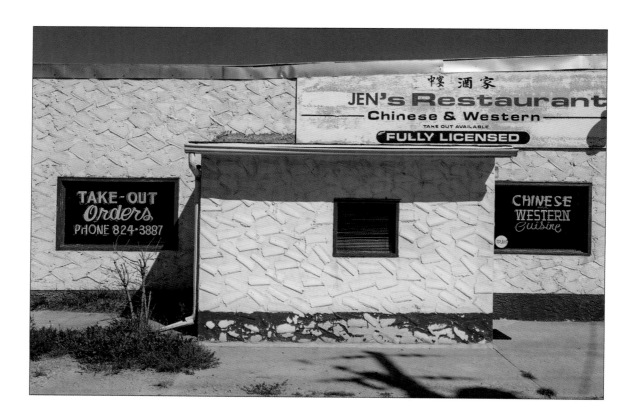

Nobleford, Alberta, 2012

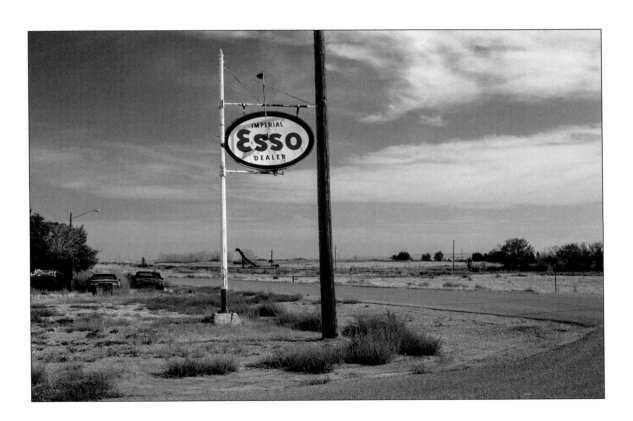

Seven Persons, Alberta, 2001

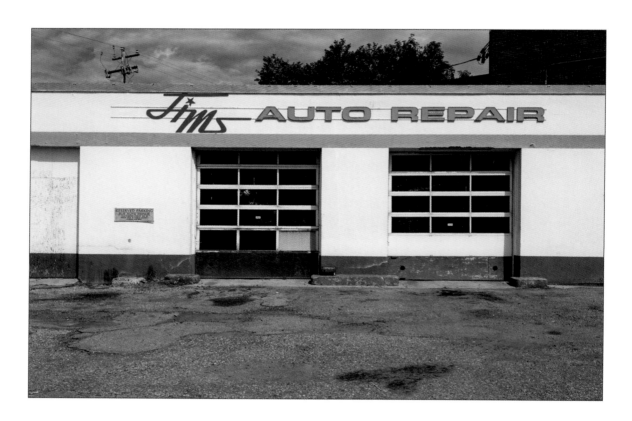

Drumheller, Alberta, 2012

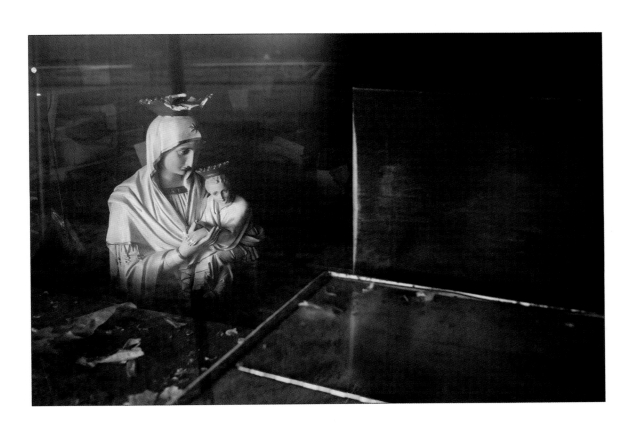

Dorothy, Alberta, 2010

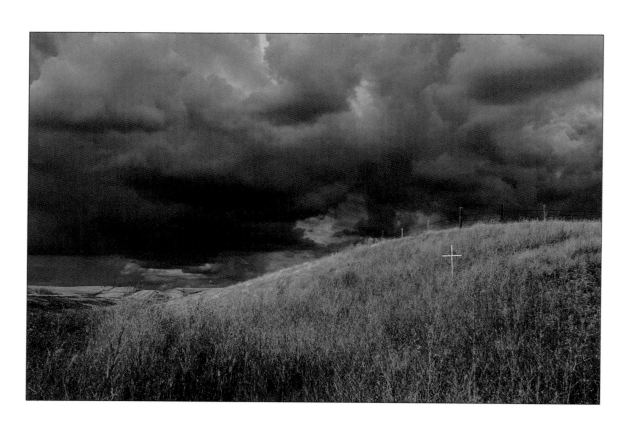

Near Hilda, Alberta, 2007

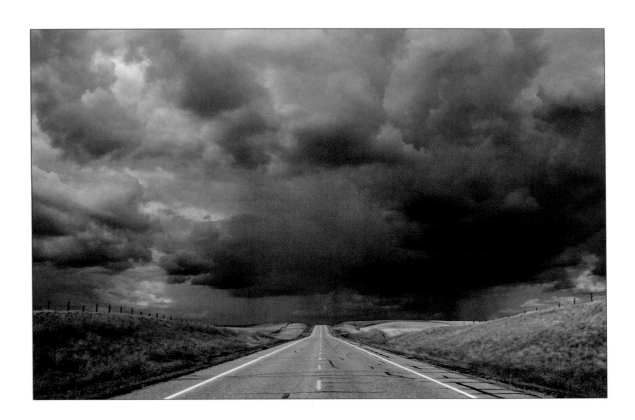

Near Hilda, Alberta, 2007

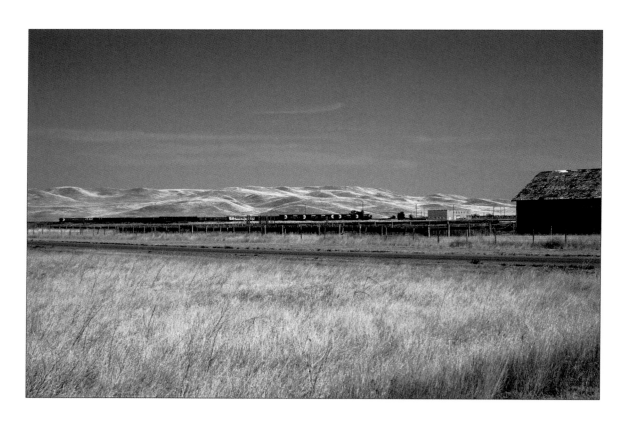

Walsh, Alberta, 2003

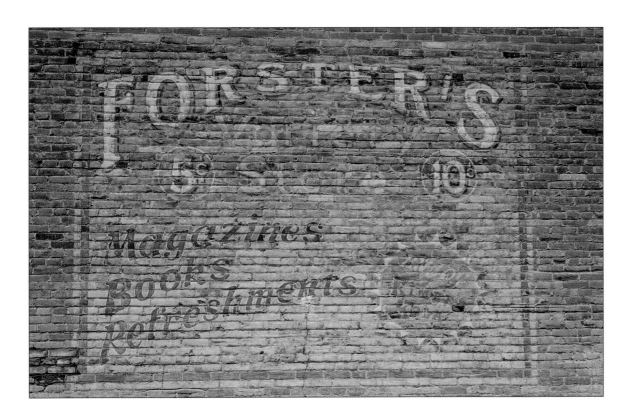

Fort Macleod, Alberta, 2012

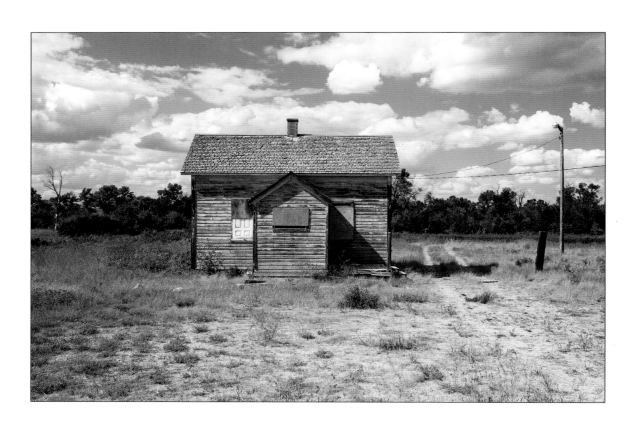

Standoff, Alberta, 2006

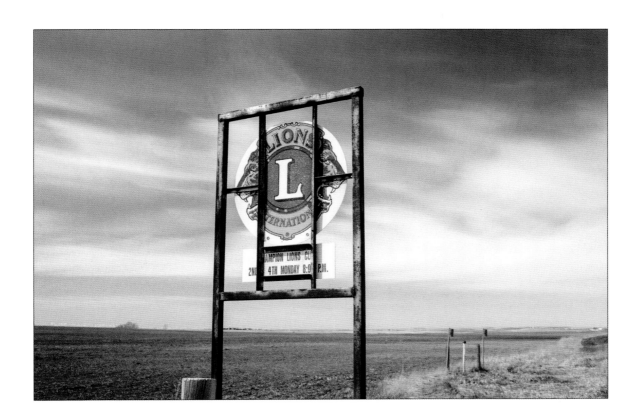

Champion, Alberta, 2003

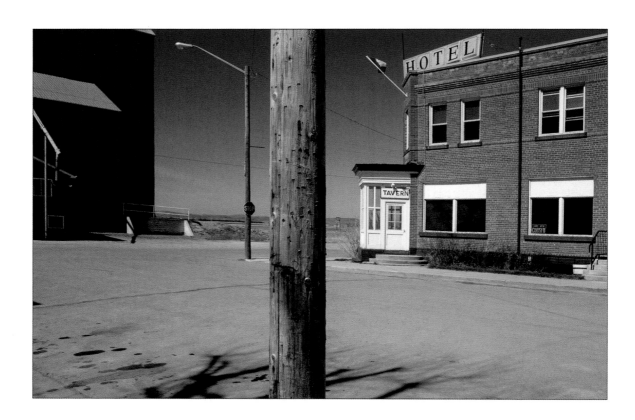

Stavely, Alberta, 2003

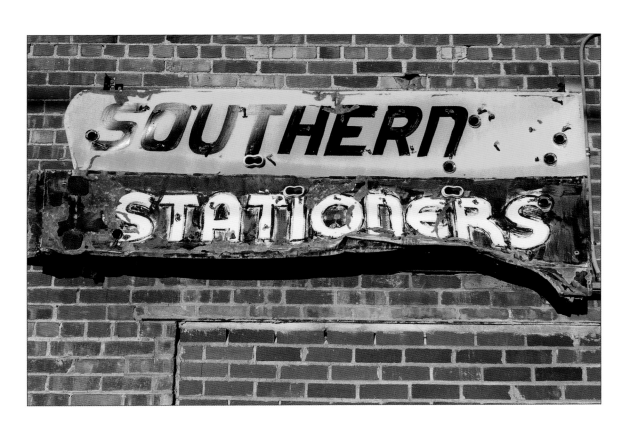

Lethbridge, Alberta, 2010

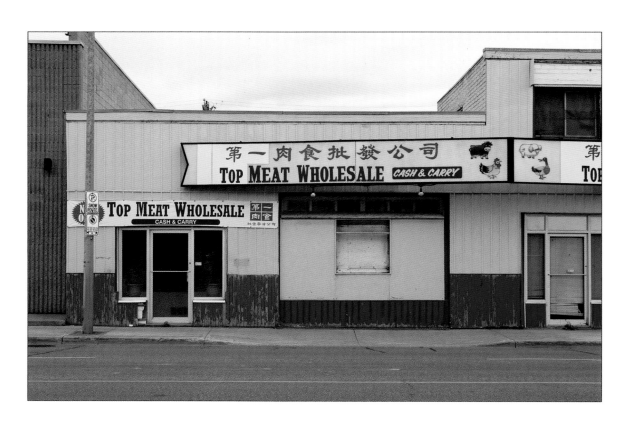

Edmonton, Alberta, 2008

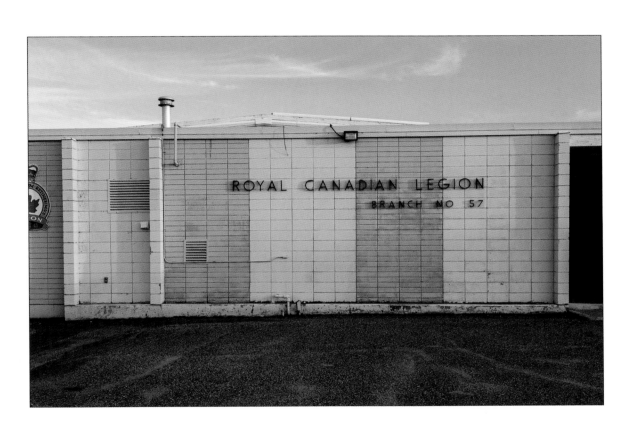

Camrose, Alberta, 2012

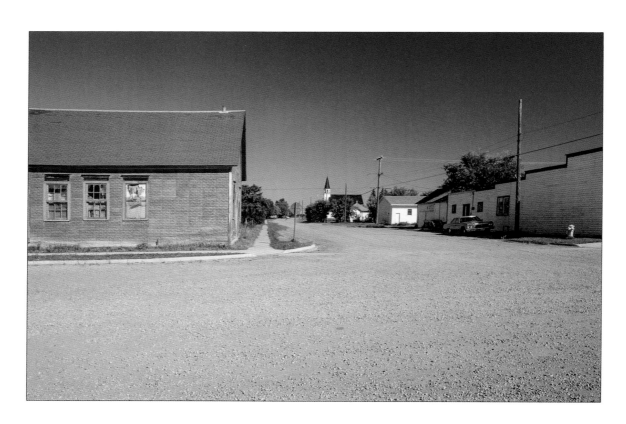

New Norway, Alberta, 1986

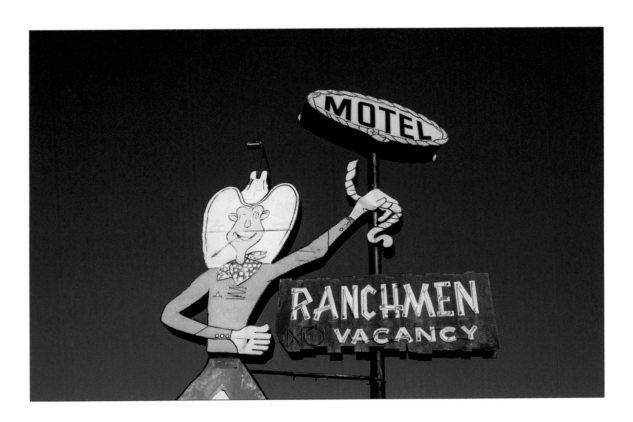

Medicine Hat, Alberta, 2012

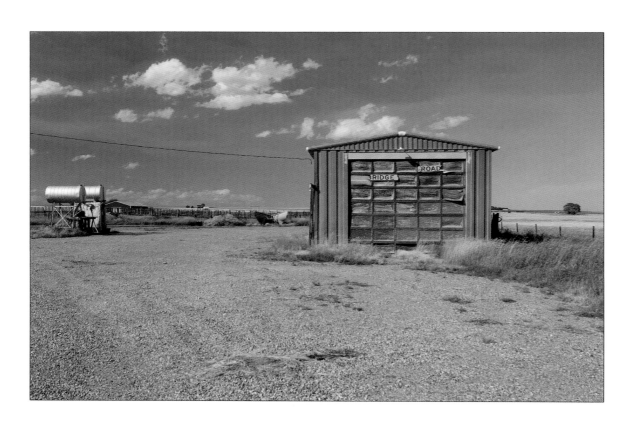

Glenwood, Alberta, 2005

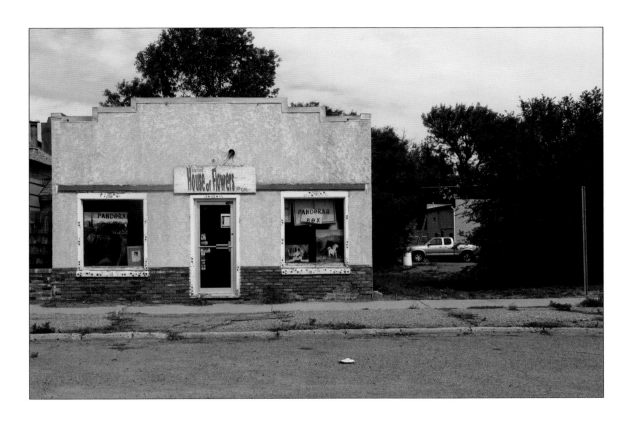

Bow Island, Alberta, 2008

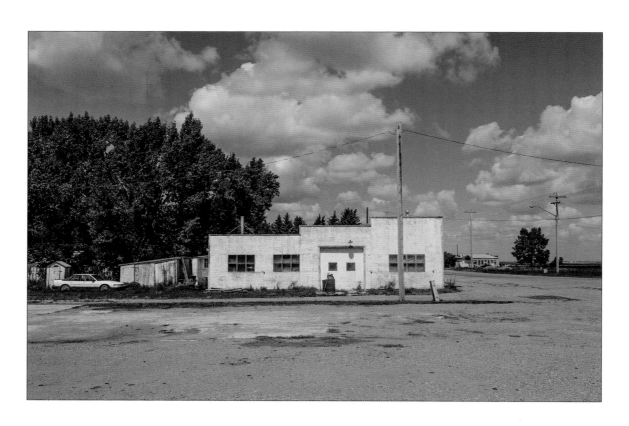

Iron Springs, Alberta, 2012

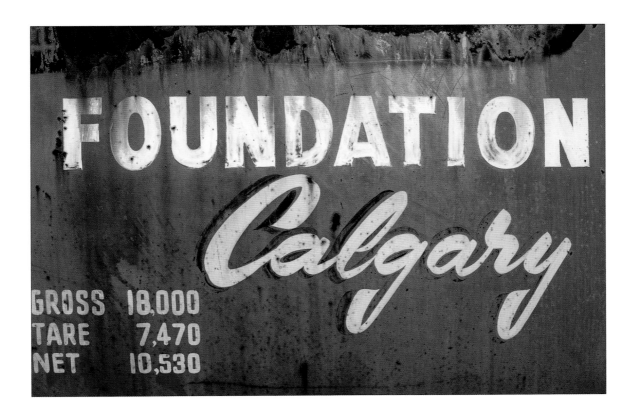

Huxley, Alberta, 2012

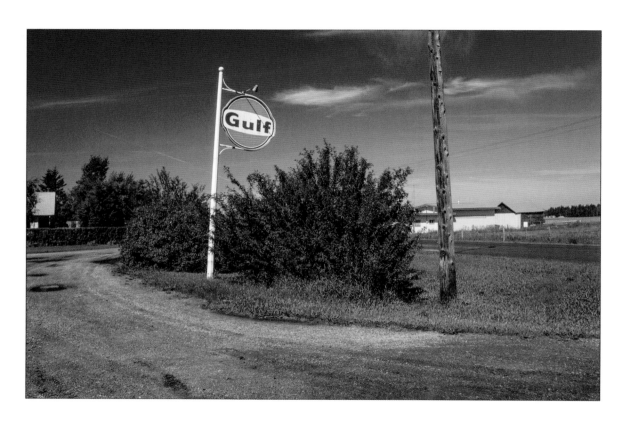

Josephburg, Alberta, 1987

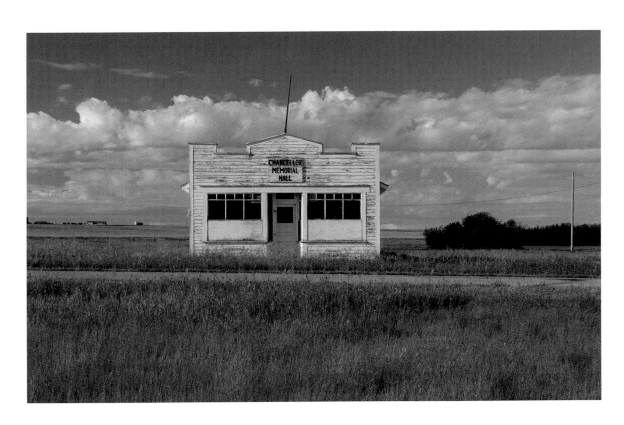

Chancellor, Alberta, 2009

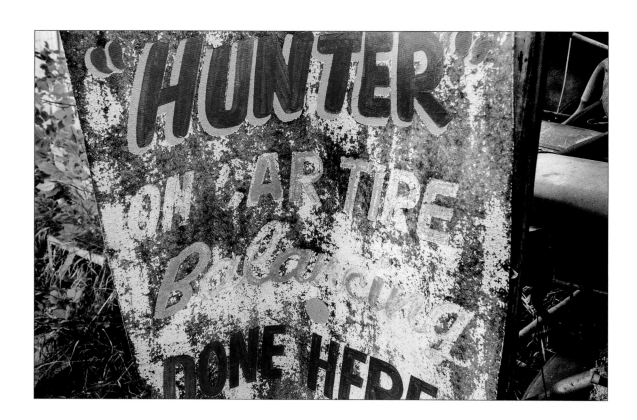

Chin, Alberta, 2004

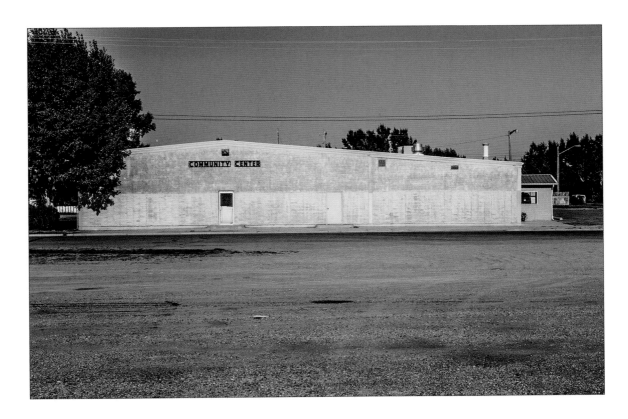

Stavely, Alberta, 2008

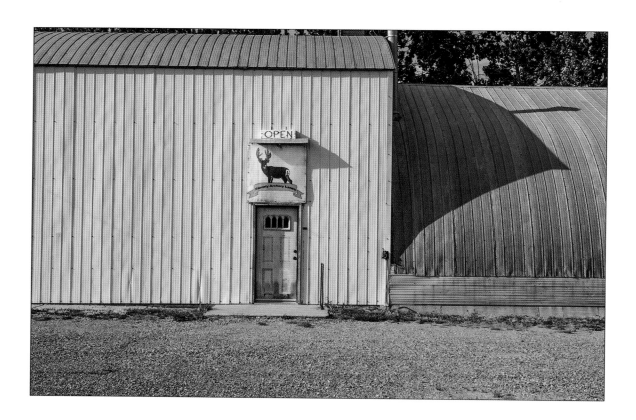

Stavely, Alberta, 2008

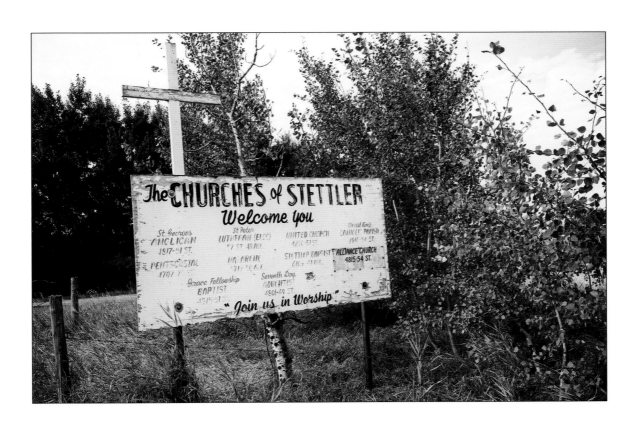

Stettler, Alberta, 2012

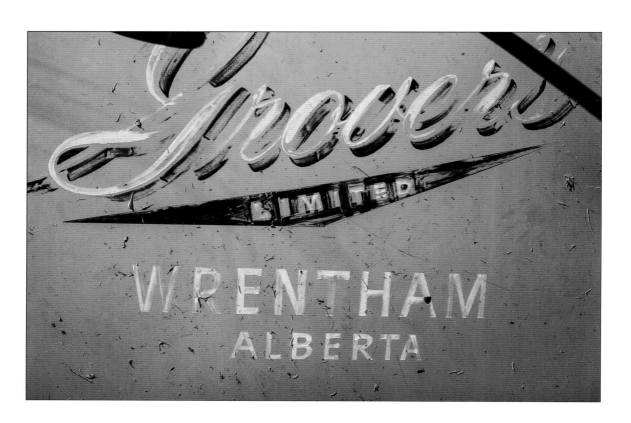

Wrentham, Alberta, 2012

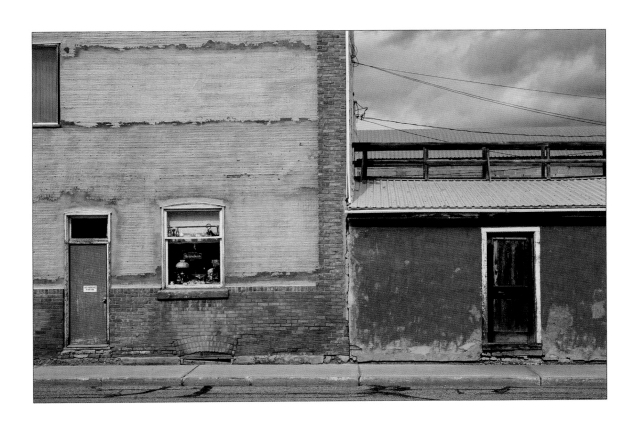

Viking, Alberta, 2007

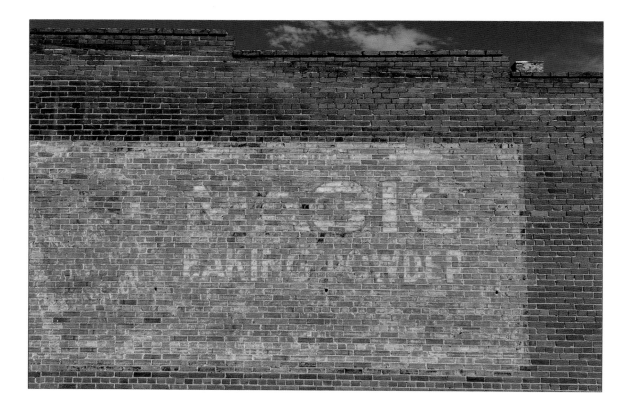

Irvine, Alberta, 2004

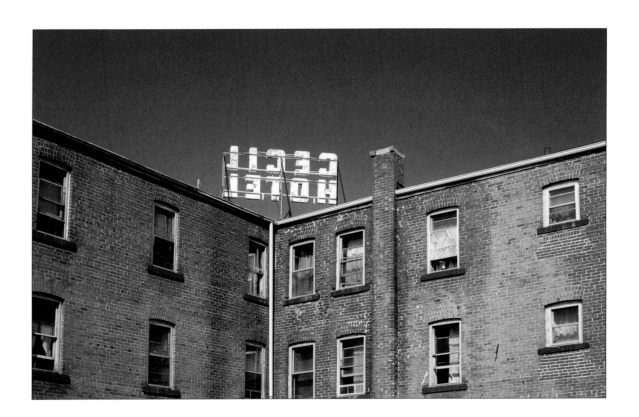

Medicine Hat, Alberta, 2003

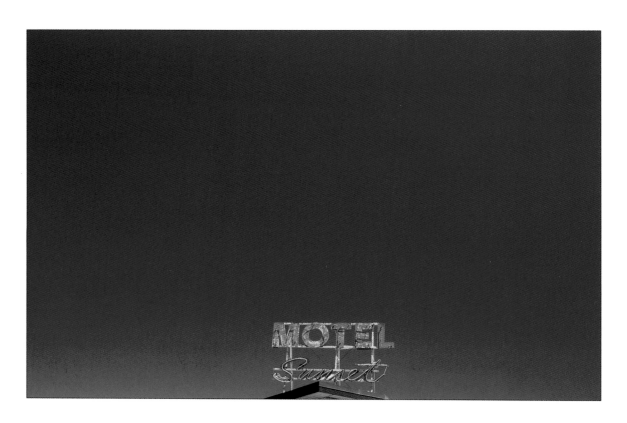

Fort Macleod, Alberta, 2010

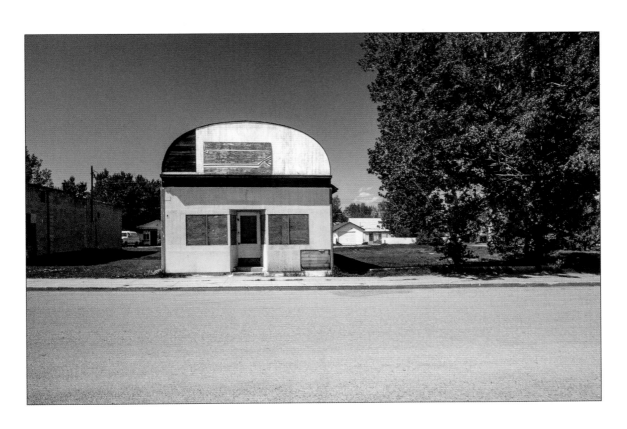

Stavely, Alberta, 1993

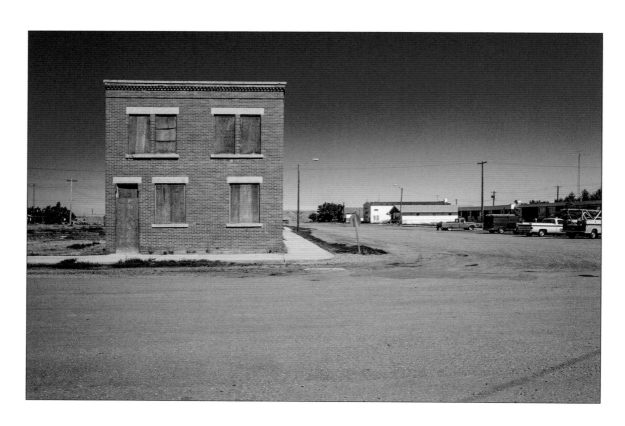

Empress, Alberta, 1987

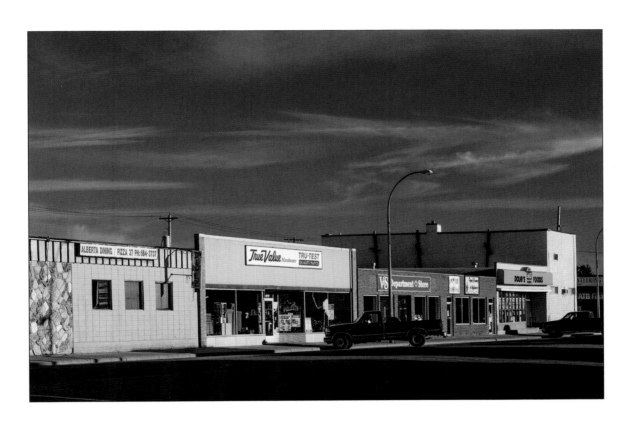

Oyen, Alberta, 2007

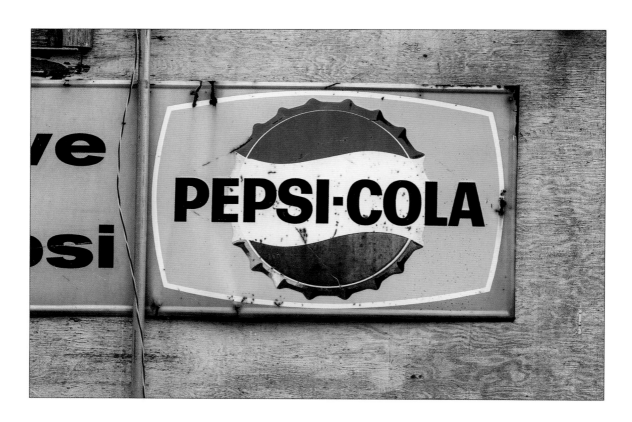

Hairy Hill, Alberta, 2007

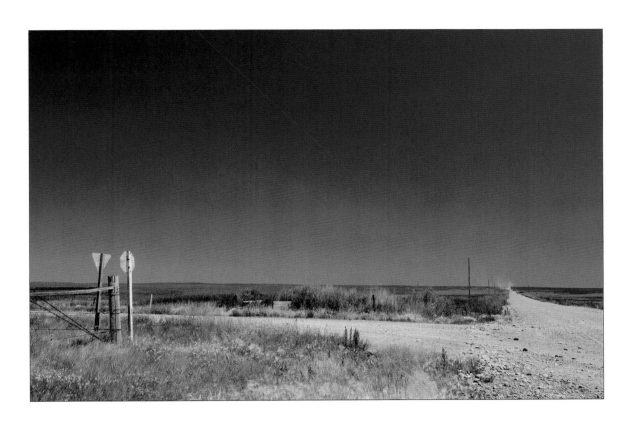

Kainai Reserve, Alberta, 2007

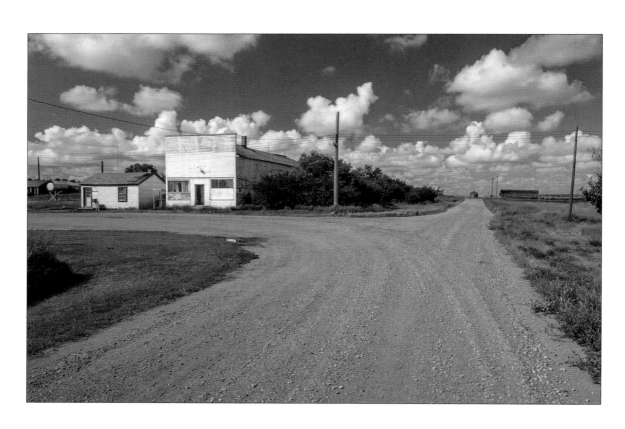

New Brigden, Alberta, 1993

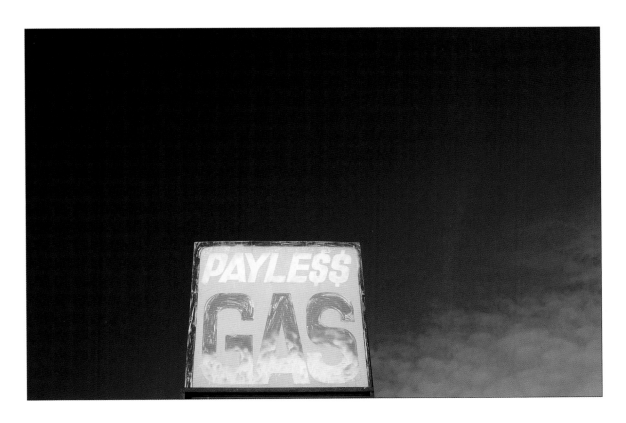

Calgary, Alberta, 2011

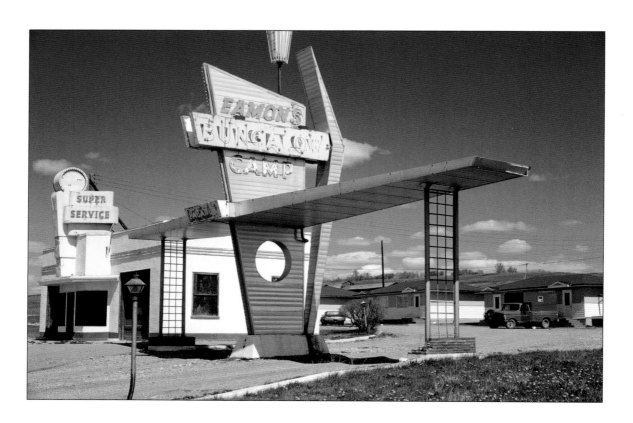

Calgary, Alberta, 1984

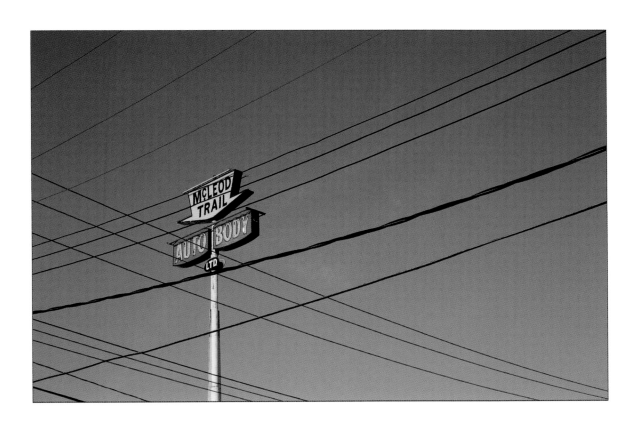

Calgary, Alberta, 2012

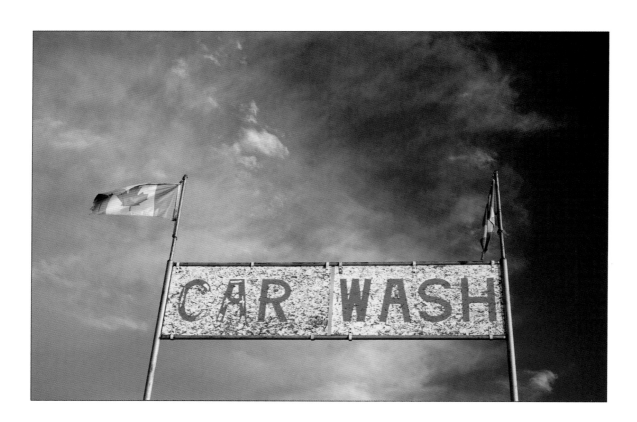

Calgary, Alberta, 2011

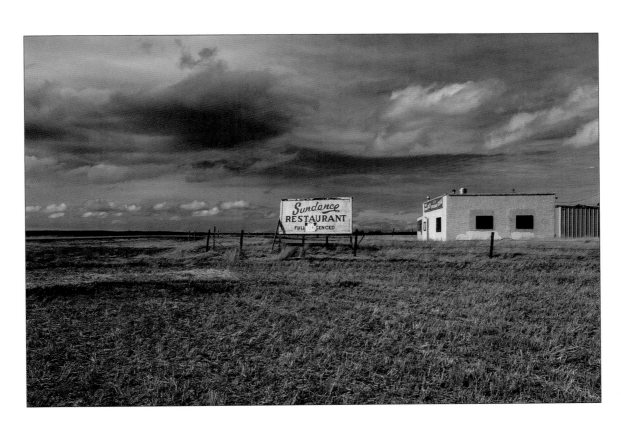

Near Standoff, Alberta, 2006

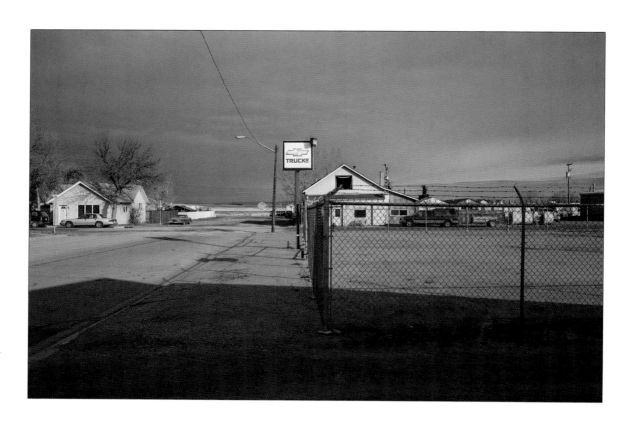

Acme, Alberta, 2010

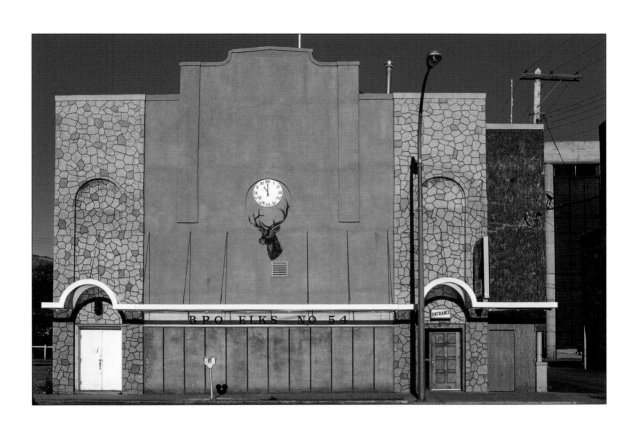

Drumheller, Alberta, 1979

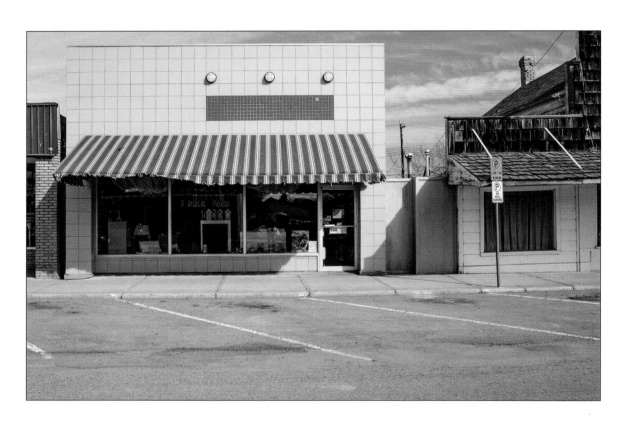

Claresholm, Alberta, 2001

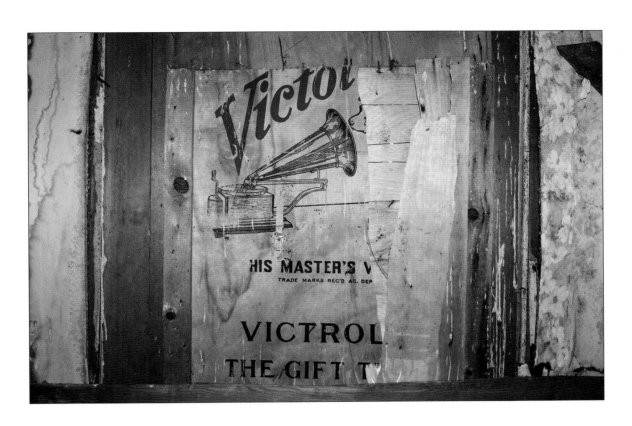

Near Champion, Alberta, 2004

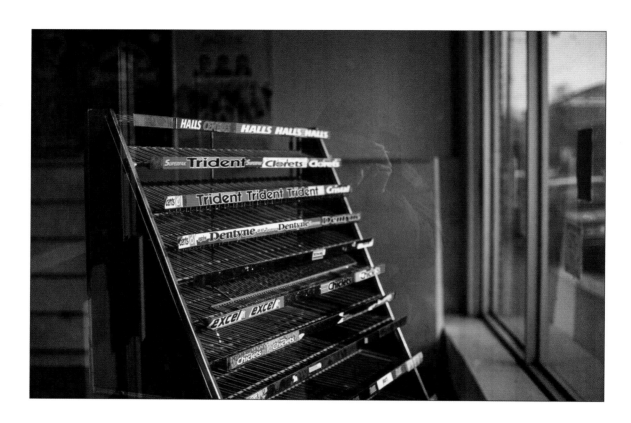

Vulcan, Alberta, 2002

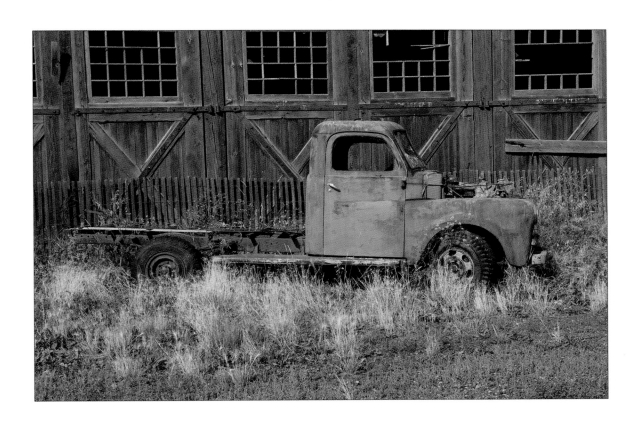

Hanna, Alberta, 2007

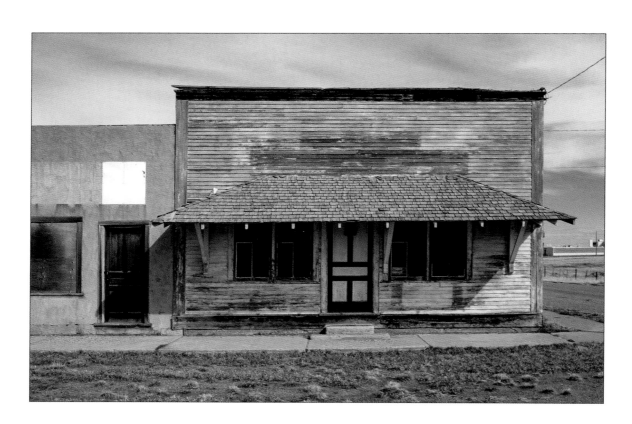

Etzikom, Alberta, 1988

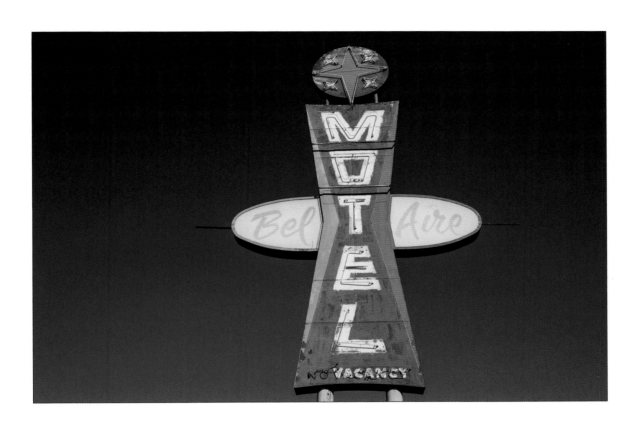

Medicine Hat, Alberta, 2012

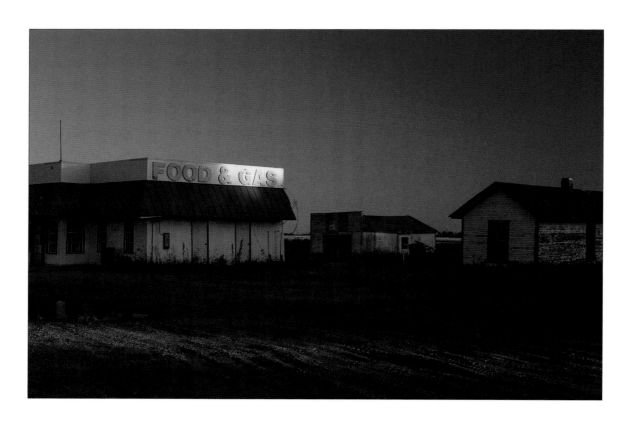

Holden, Alberta, 2007

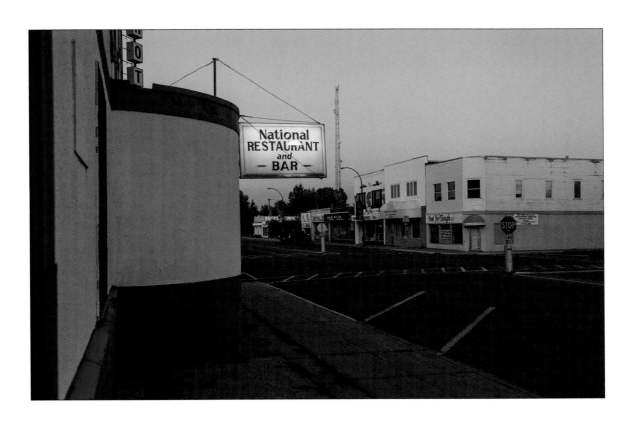

Hanna, Alberta, 2011

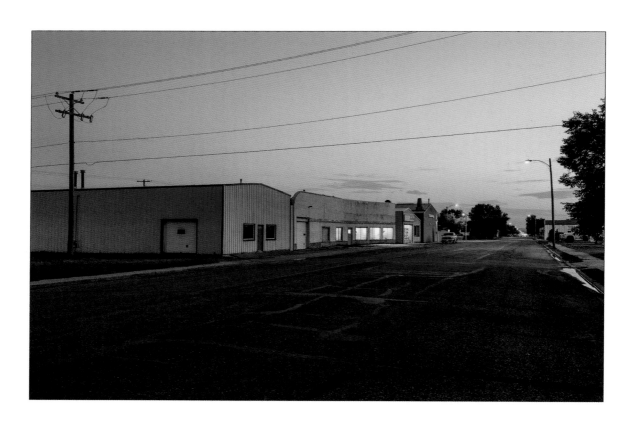

Hanna, Alberta, 2012

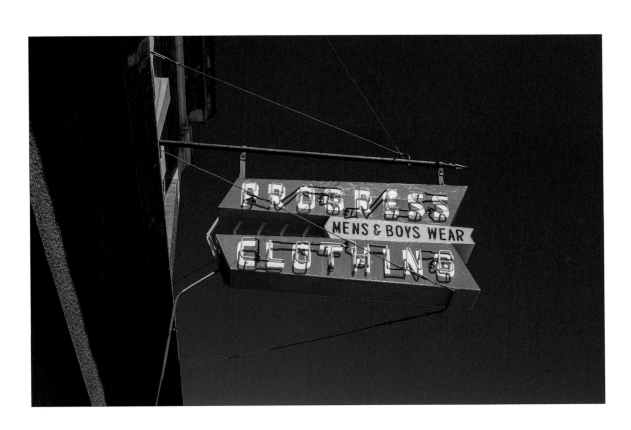

Lethbridge, Alberta, 2009

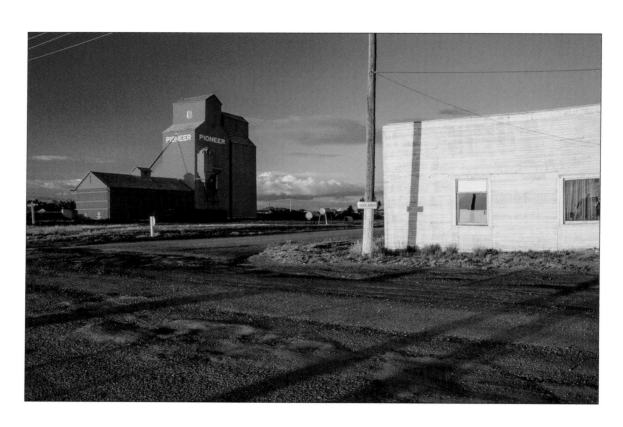

Cereal, Alberta, 1987

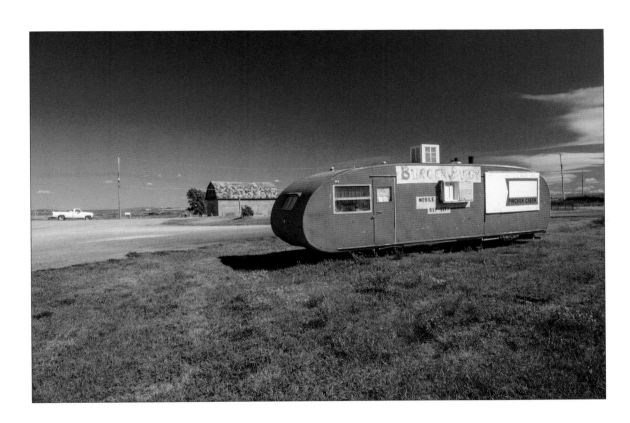

Lundbreck, Alberta, 1997

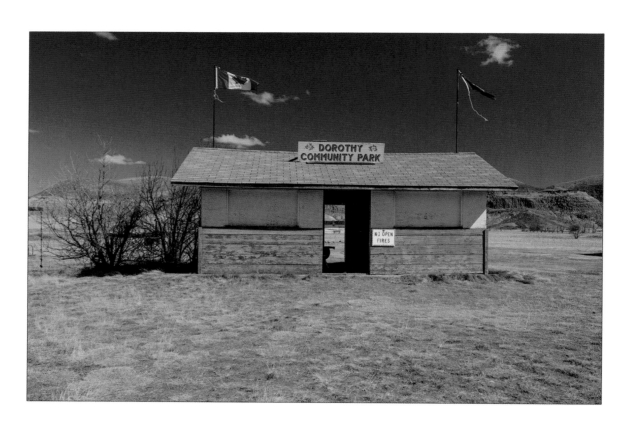

Dorothy, Alberta, 2010

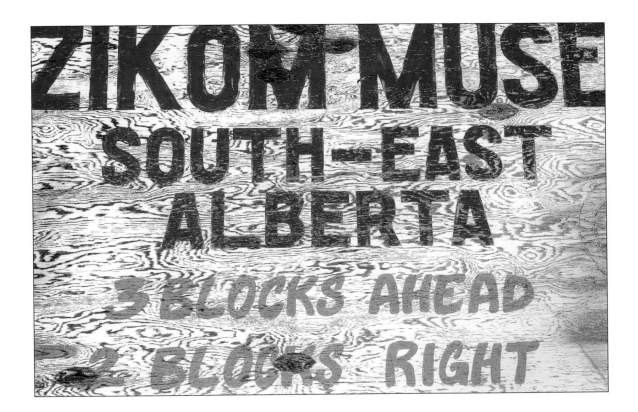

Etzikom, Alberta, 2012

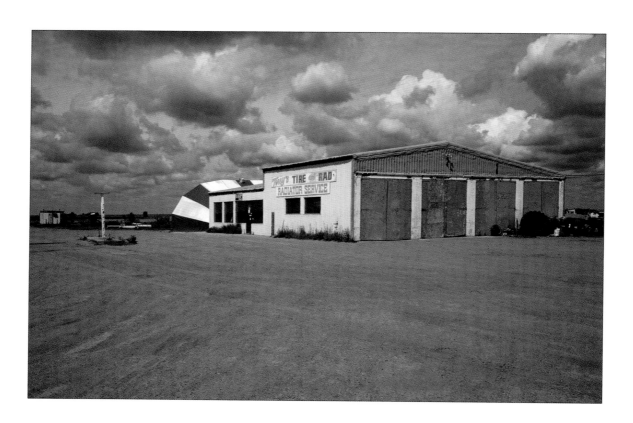

Youngstown, Alberta, 1999

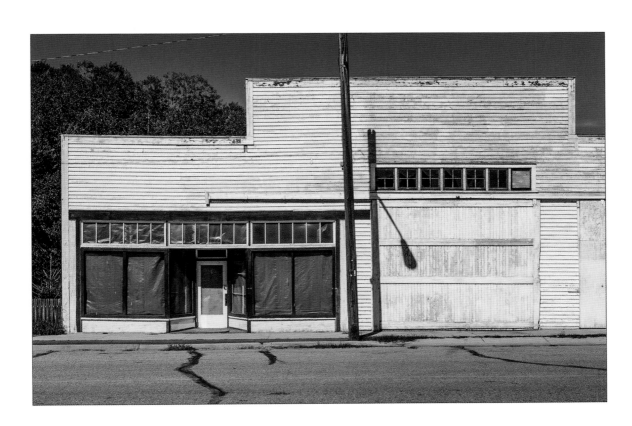

Mirror, Alberta, 2007

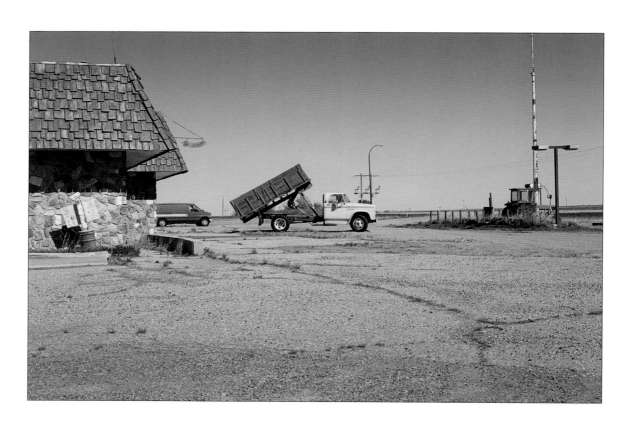

Youngstown, Alberta, 2018

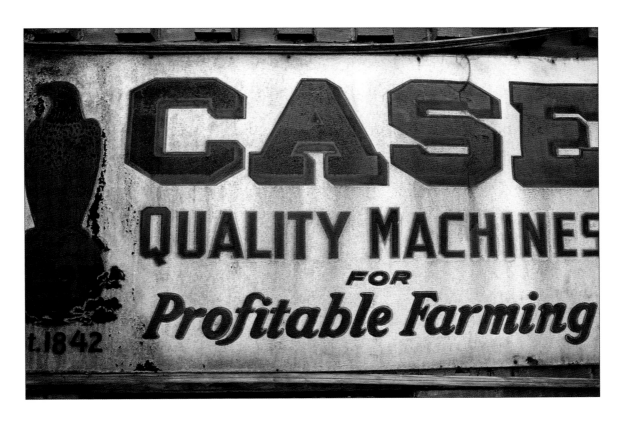

Clive, Alberta, 1984

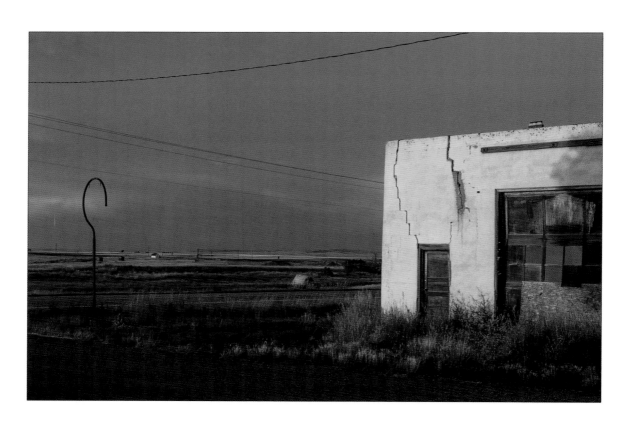

Etzikom, Alberta, 2008

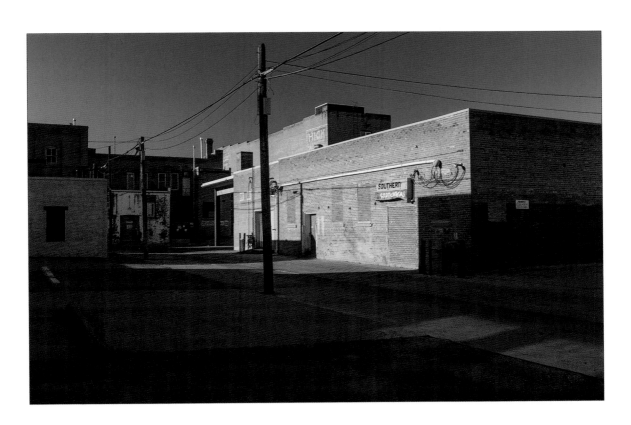

Lethbridge, Alberta, 2010

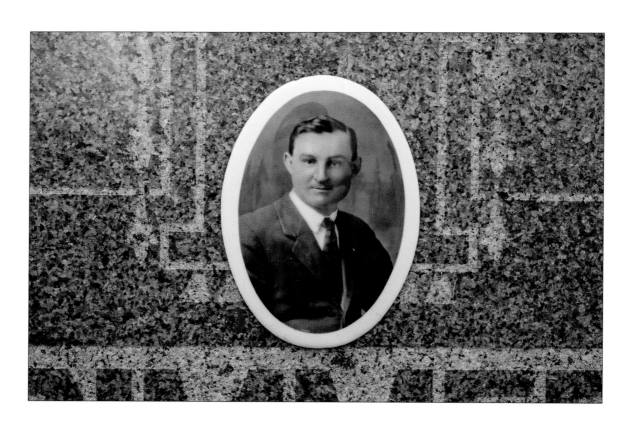

Spring Lake, Alberta, 2011

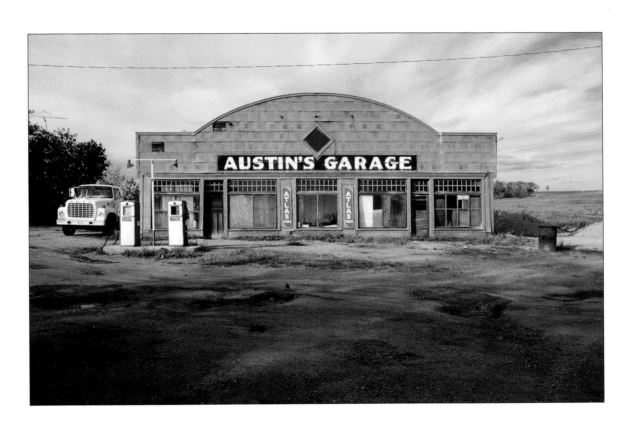

Ranfurly, Alberta, 1987

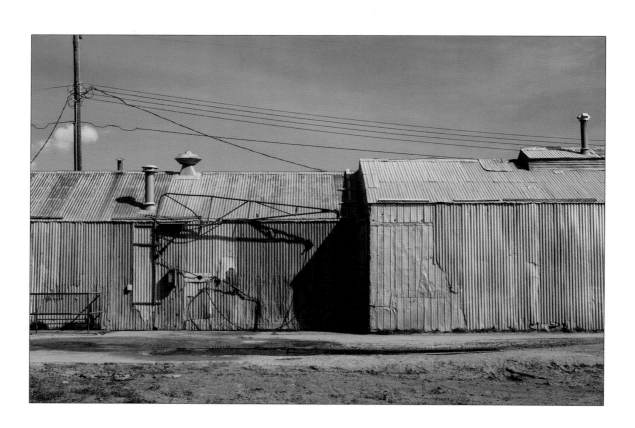

Longview, Alberta, 2008

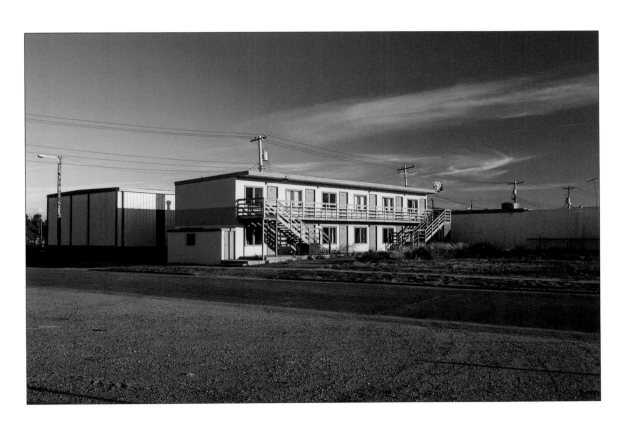

Oyen, Alberta, 2007

Byemoor, Alberta, 2012

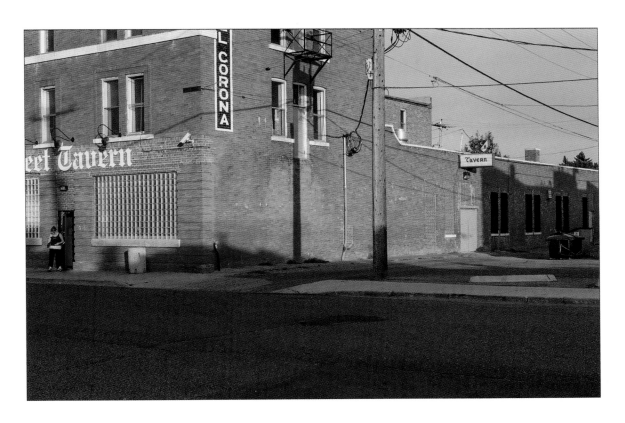

Medicine Hat, Alberta, 2008

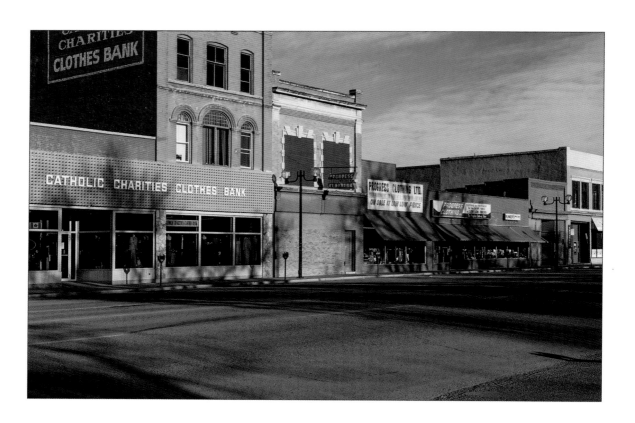

Lethbridge, Alberta, 2009

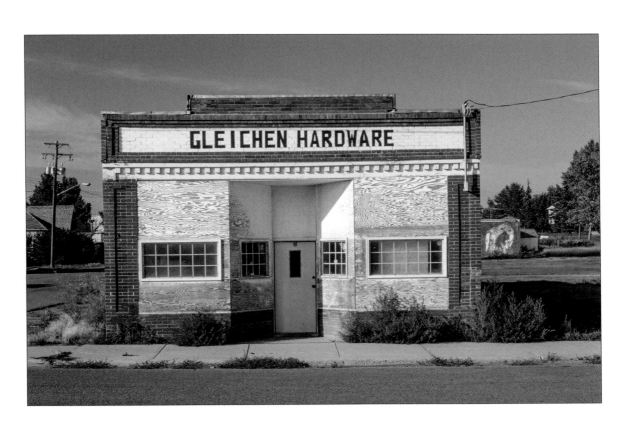

Gleichen, Alberta, 2003

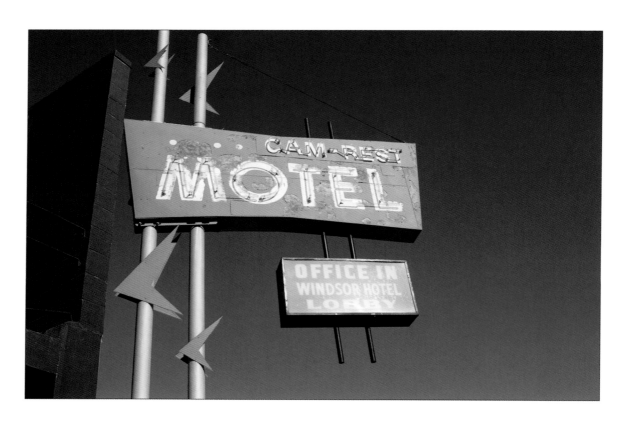

Camrose, Alberta, 2011

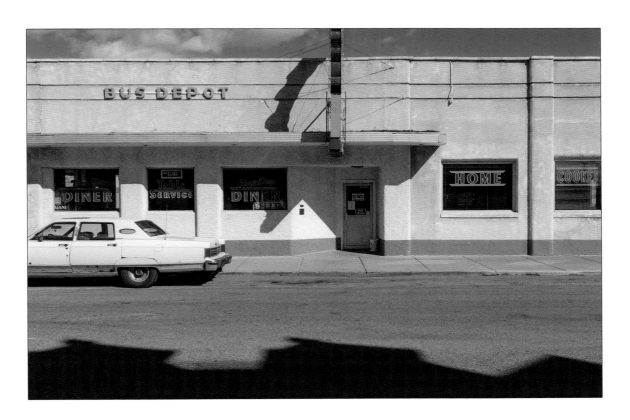

Fort Macleod, Alberta, 2004

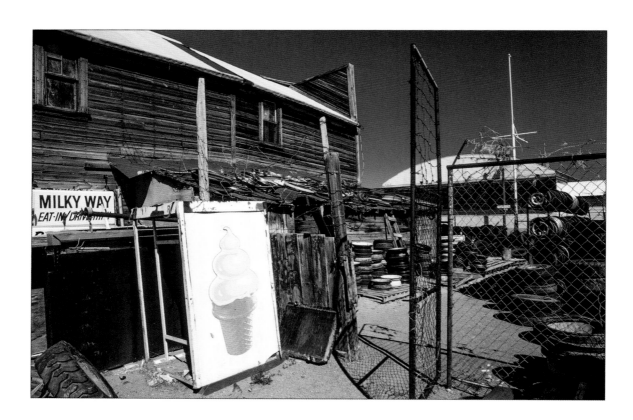

Fort Macleod, Alberta, 1997

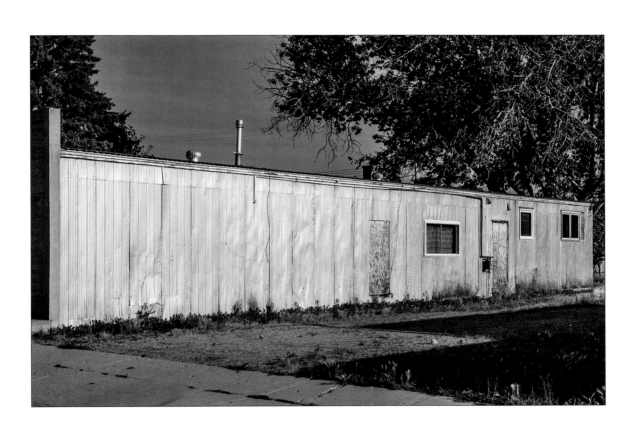

Vauxhall, Alberta, 2009

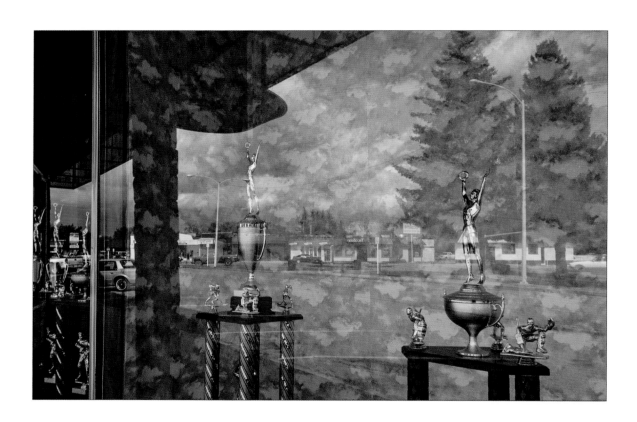

Taber, Alberta, 2004

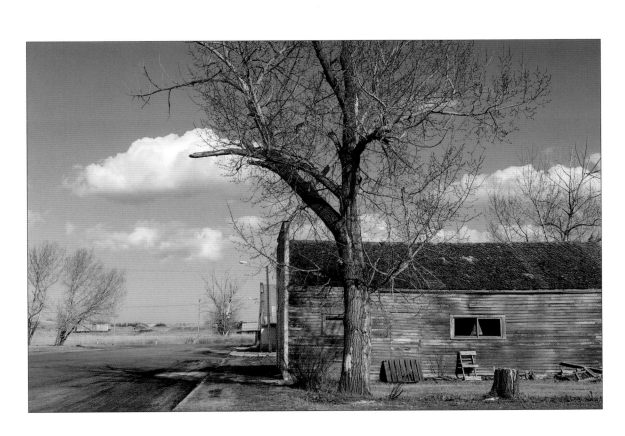

Rumsey, Alberta, 2008

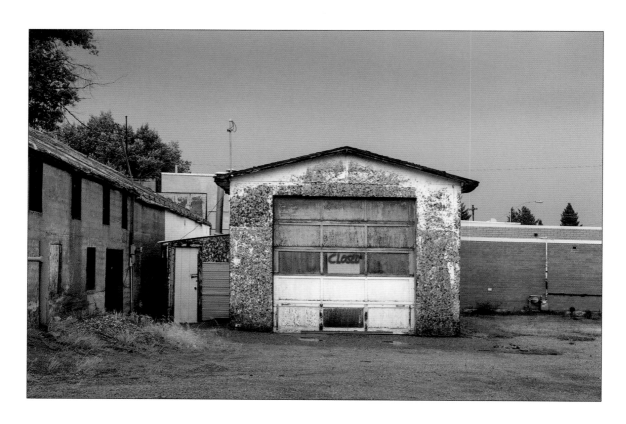

Milk River, Alberta, 2008

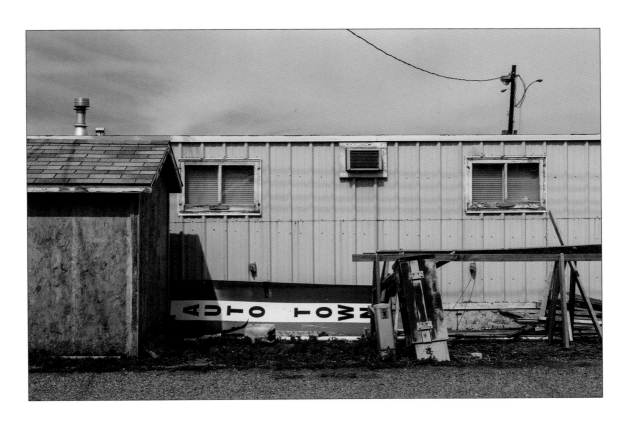

Coaldale, Alberta, 2009

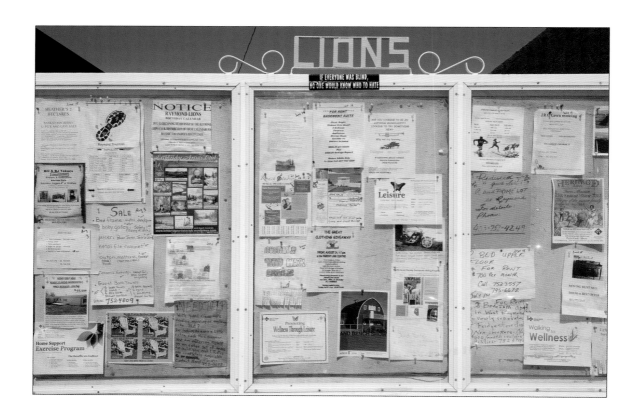

Raymond, Alberta, 2012

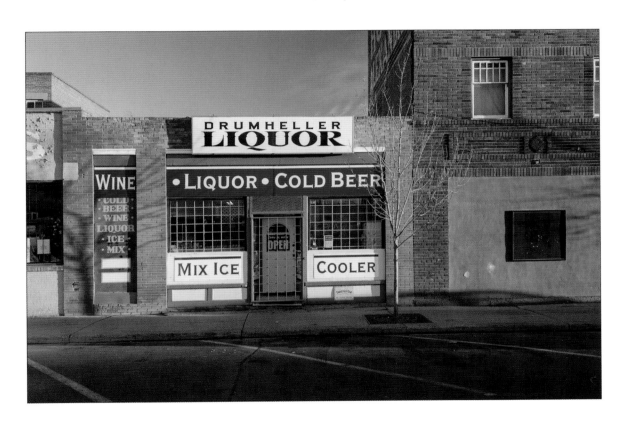

Drumheller, Alberta, 2010

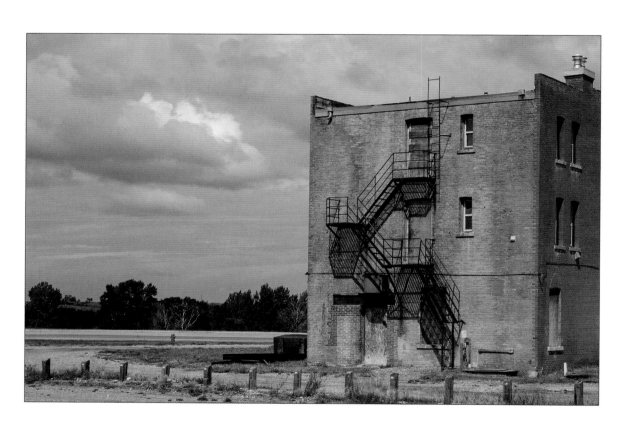

Fort Macleod, Alberta, 2009

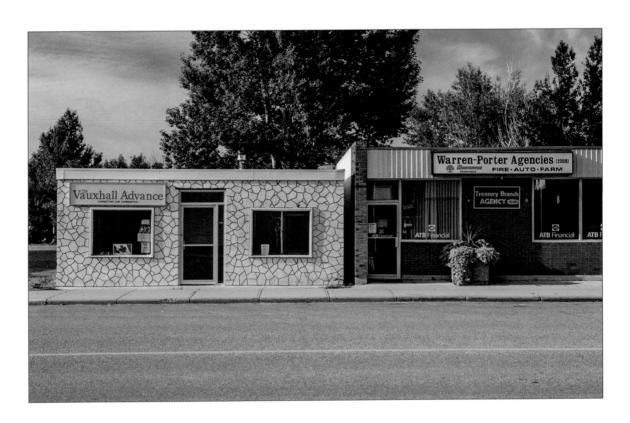

Vauxhall, Alberta, 2009

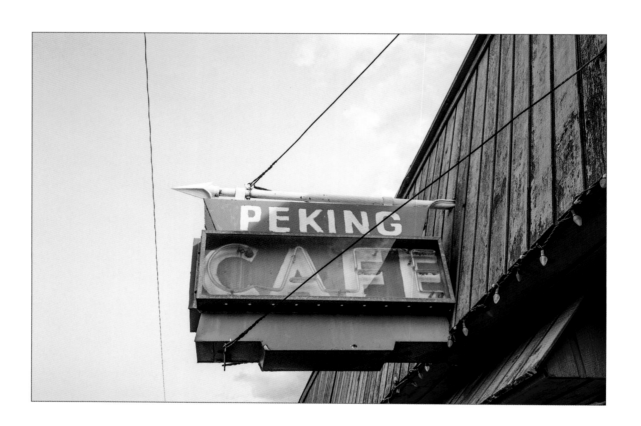

Trochu, Alberta, 2012

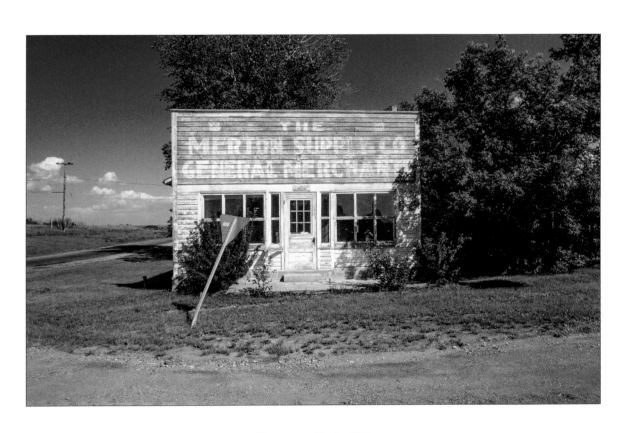

Rivercourse, Alberta, 1987

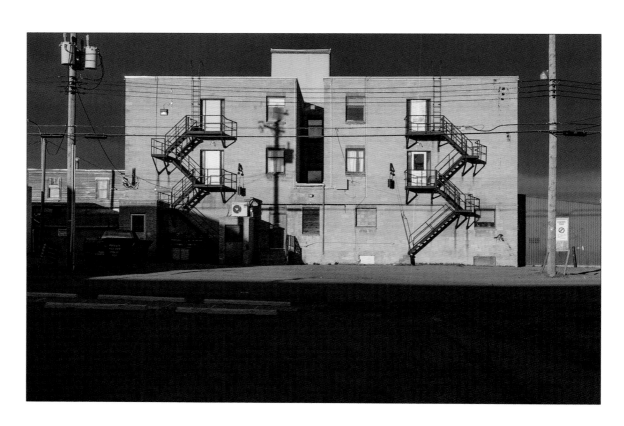

Claresholm, Alberta, 2009

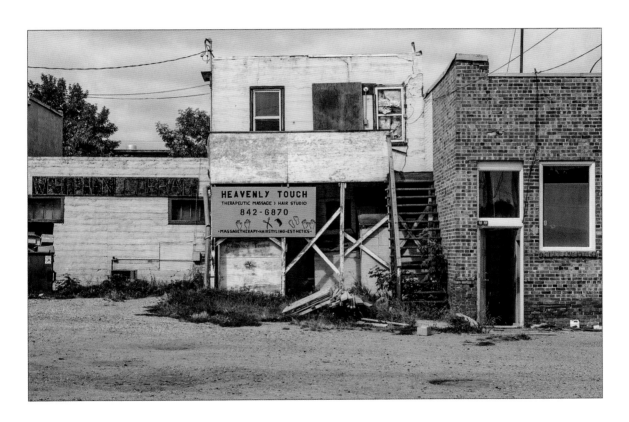

Wainwright, Alberta, 2007

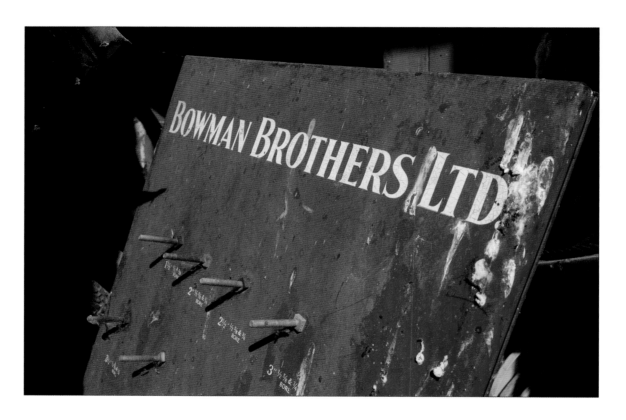

Chin, Alberta, 2011

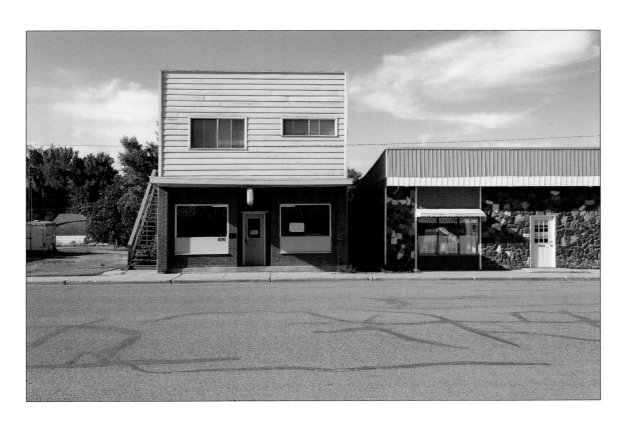

Bassano, Alberta, 2011

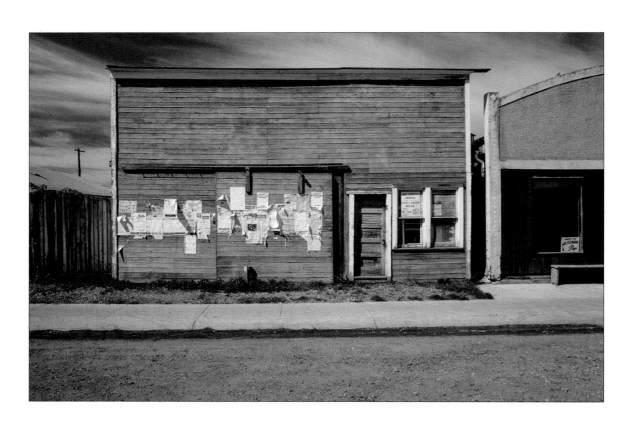

Chipman, Alberta, 1987

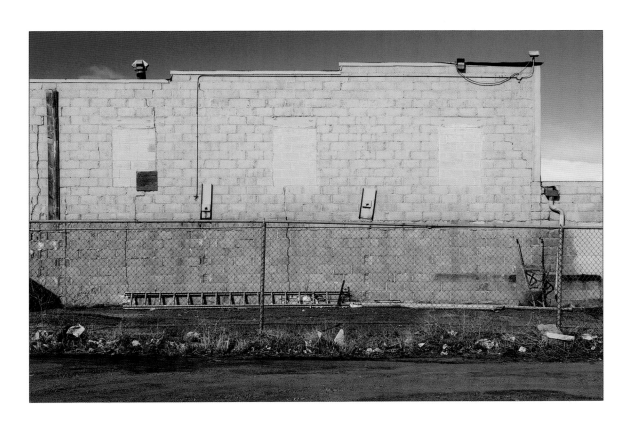

Lethbridge, Alberta, 2009

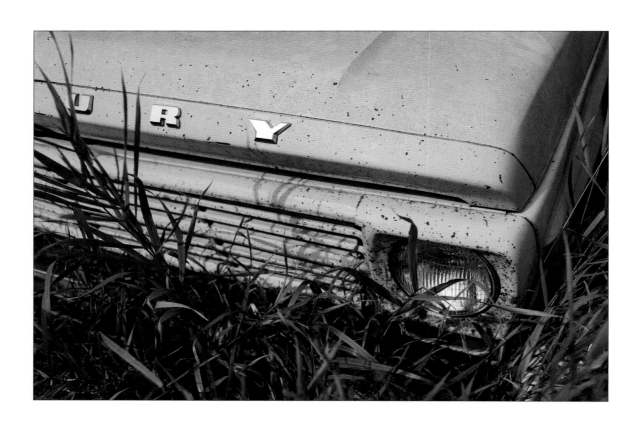

Chin, Alberta, 2011

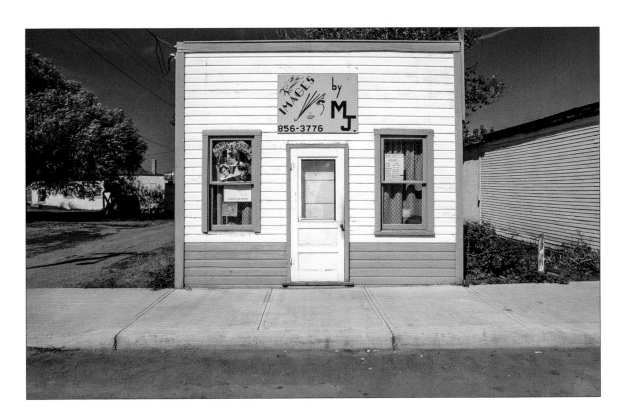

Hughenden, Alberta, 1986

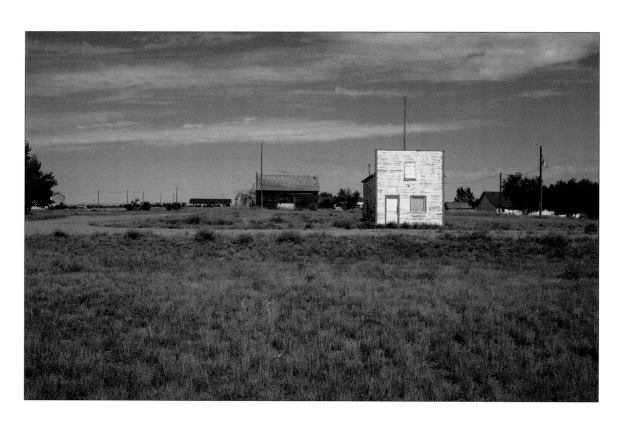

Bindloss, Alberta, 2011

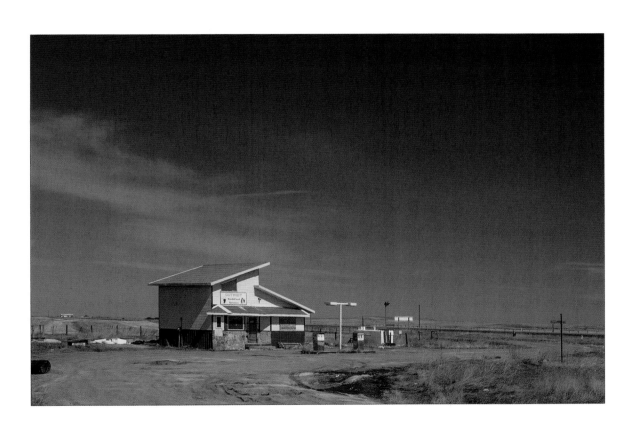

Kainai Reserve, Alberta, 2009

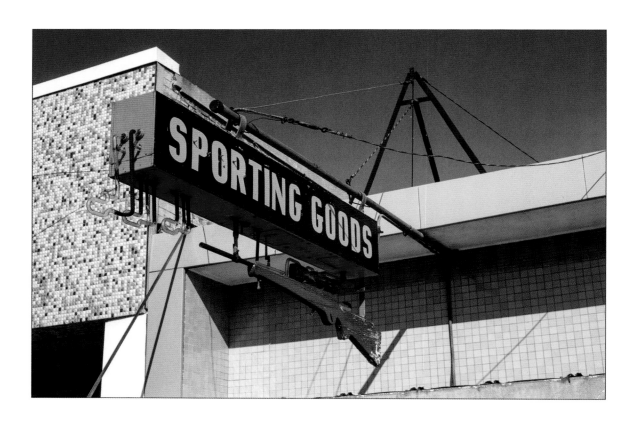

Medicine Hat, Alberta, 2003

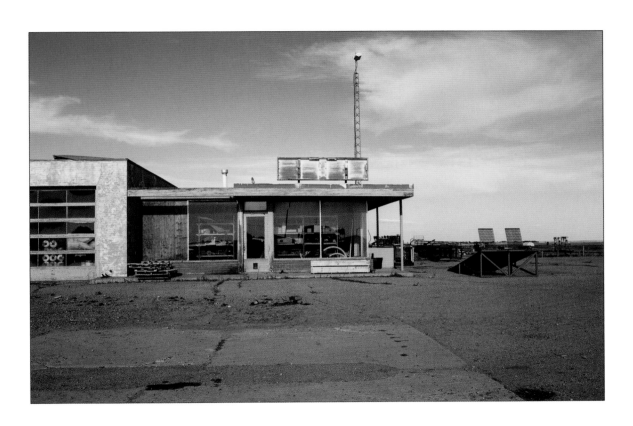

Bassano, Alberta, 2011

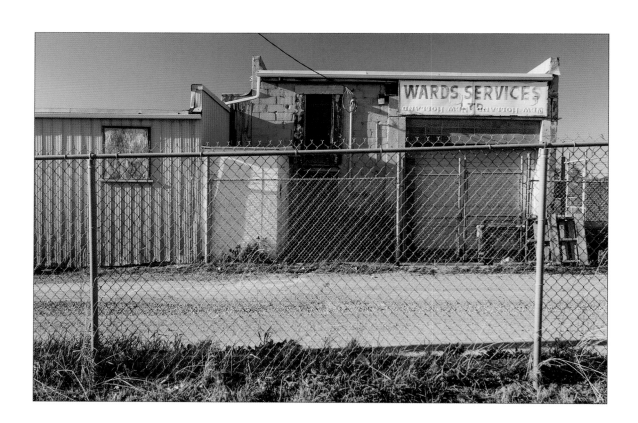

Lethbridge, Alberta, 2005

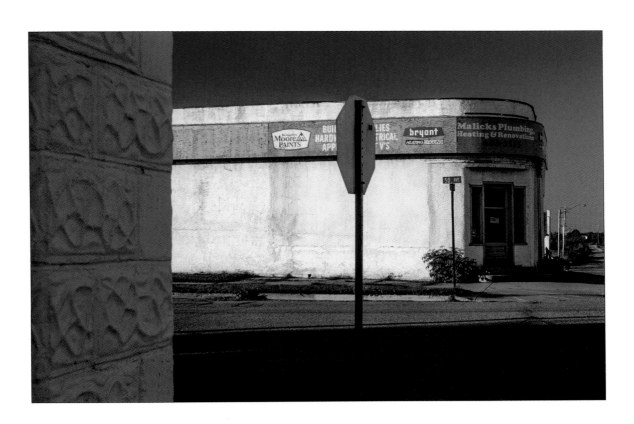

Holden, Alberta, 2007

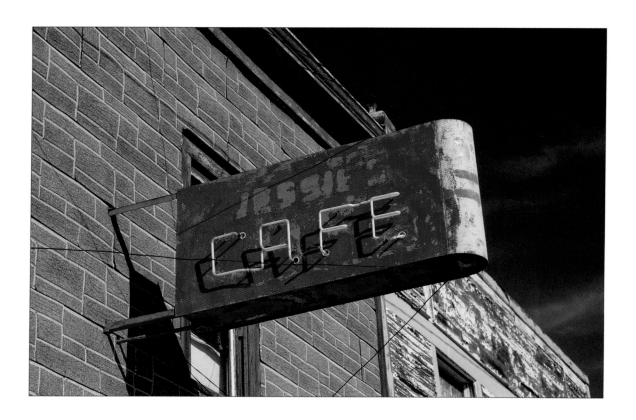

Castor, Alberta, 2007

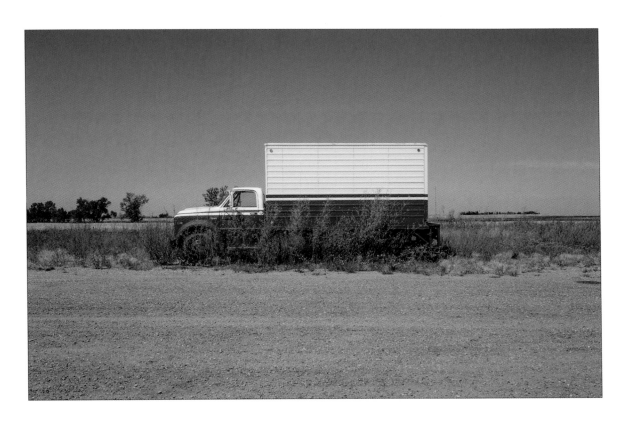

Raymond, Alberta, 2012

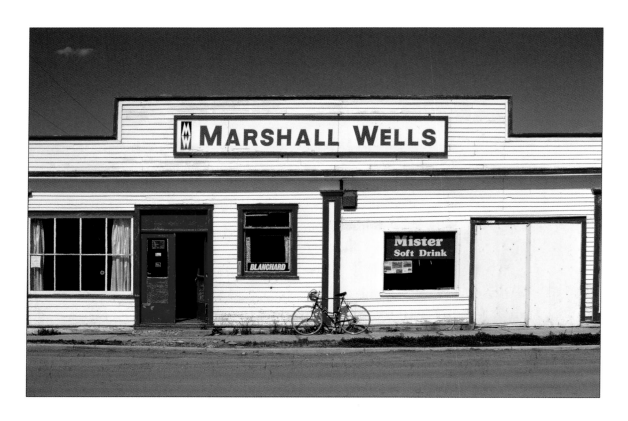

Hussar, Alberta, 1984

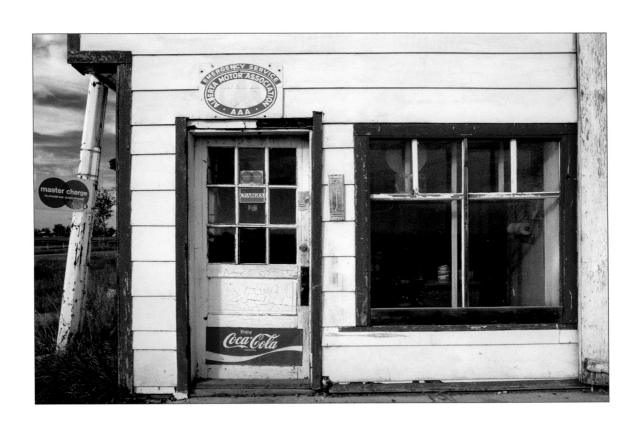

Ohaton, Alberta, 1986

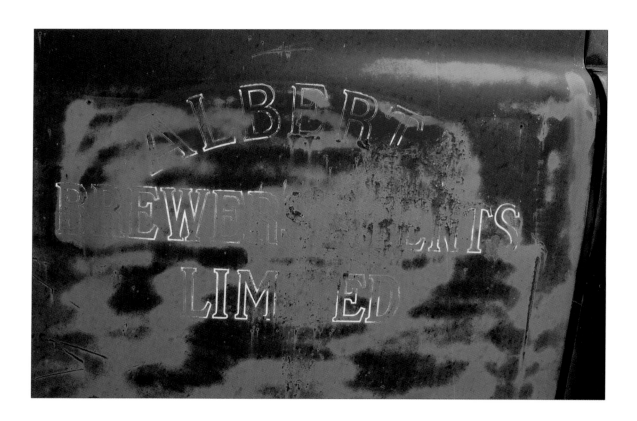

Chin, Alberta, 2004

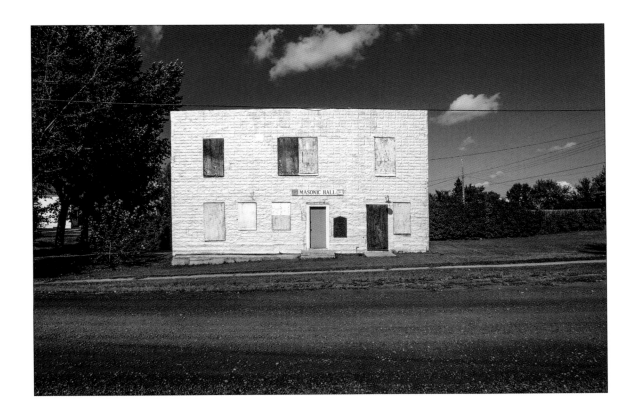

Alix, Alberta, 1991

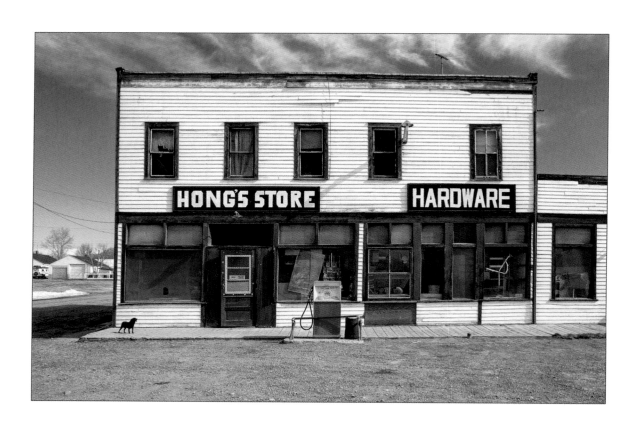

Cluny, Alberta, 1988

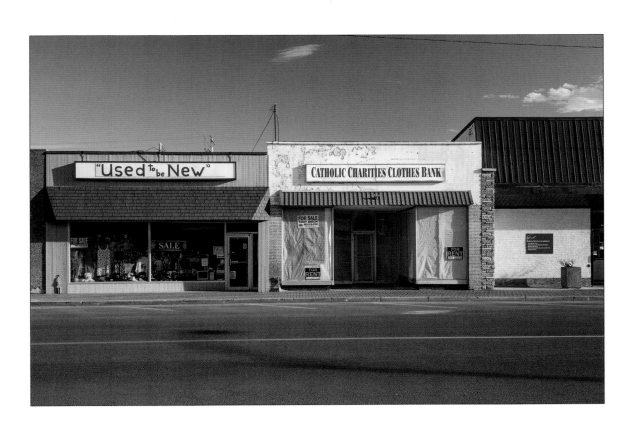

Taber, Alberta, 2011

Bindloss, Alberta, 2012

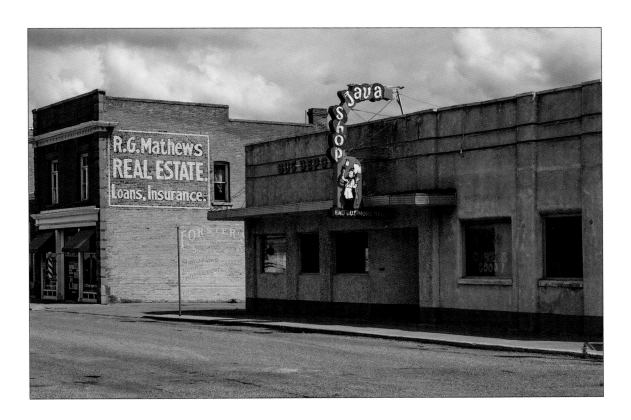

Fort Macleod, Alberta, 2009

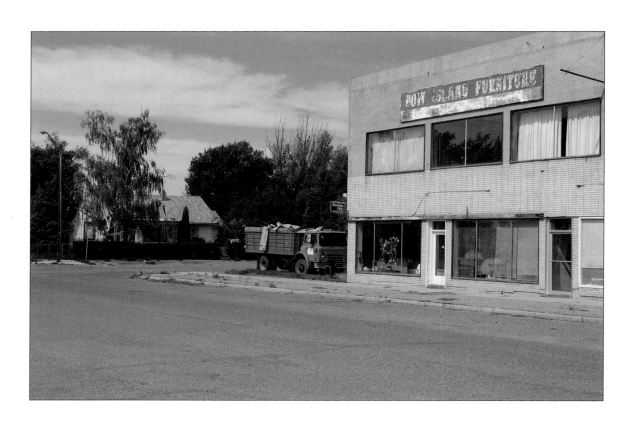

Bow Island, Alberta, 2008

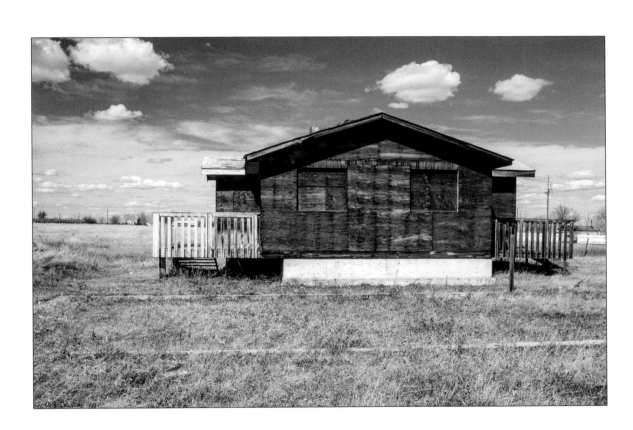

Parkland, Alberta, 2003

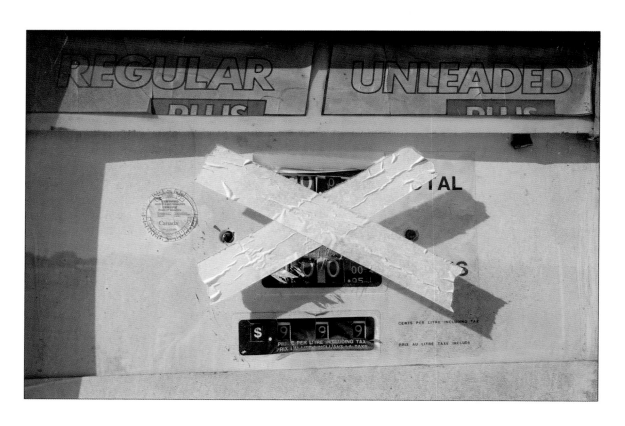

Camrose, Alberta, 2011

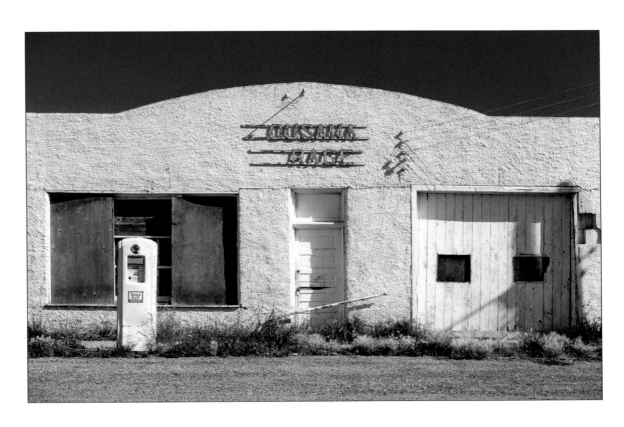

Lousana, Alberta, 1981

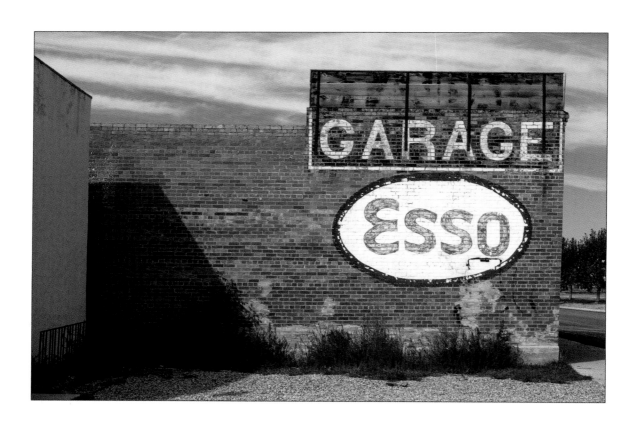

Granum, Alberta, 1985

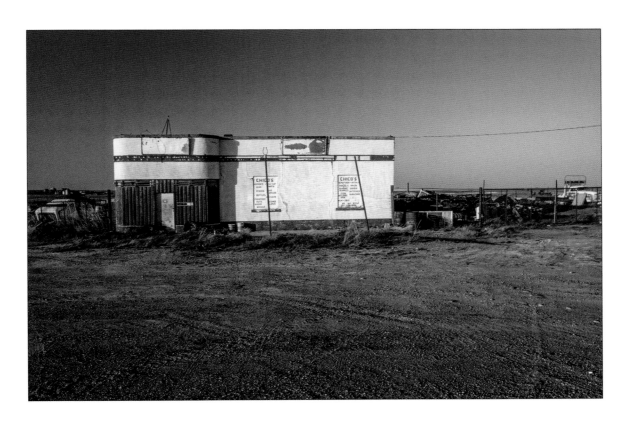

New Dayton, Alberta, 1993

Rosedale, Alberta, 2012

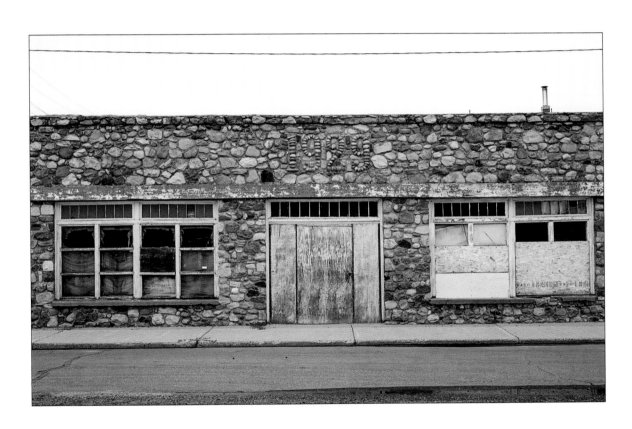

Andrew, Alberta, 2017

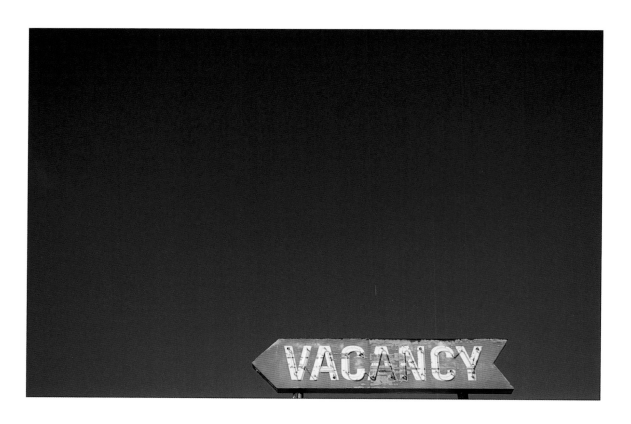

Innisfail, Alberta, 2013

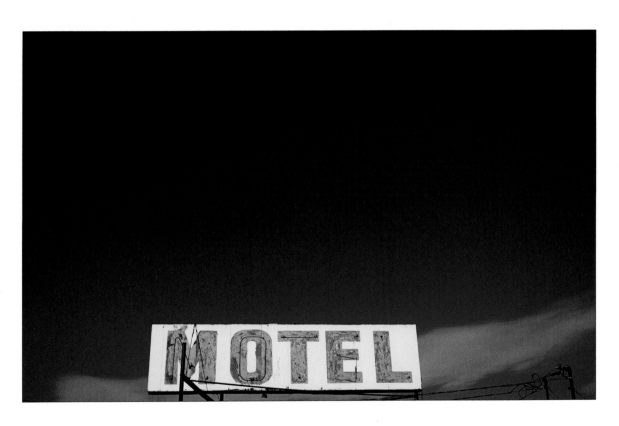

Innisfail, Alberta, 2013

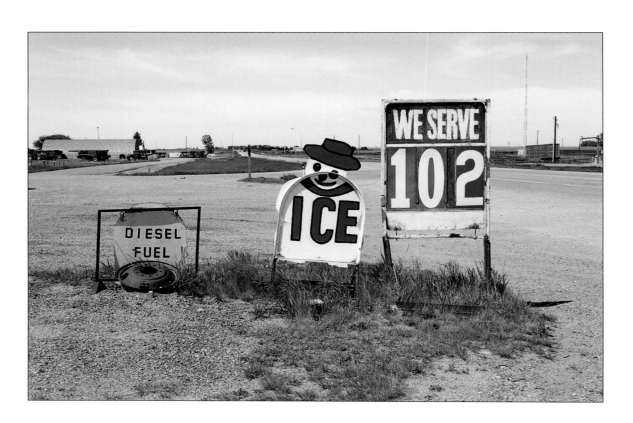

Burdett, Alberta, 2017

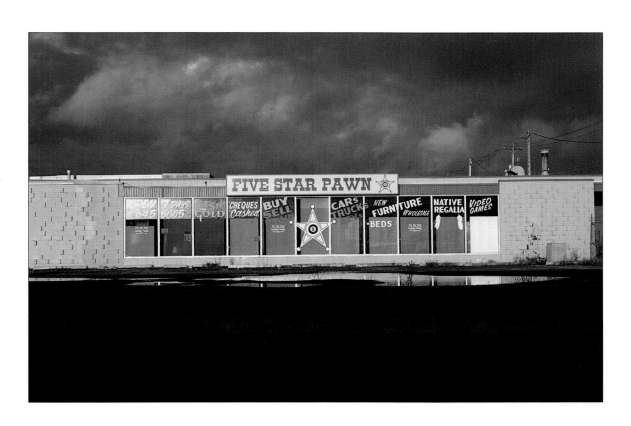

St. Paul, Alberta, 2017

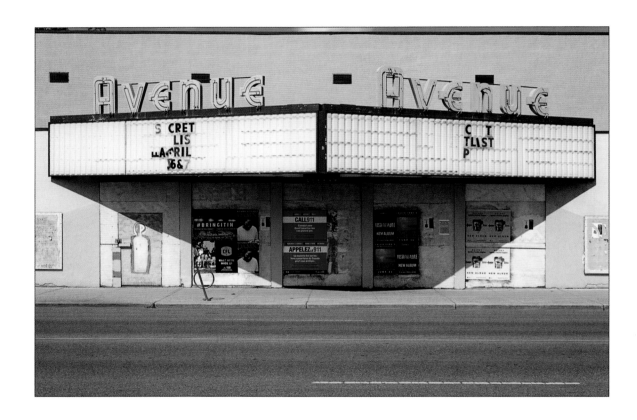

Edmonton, Alberta, 2017

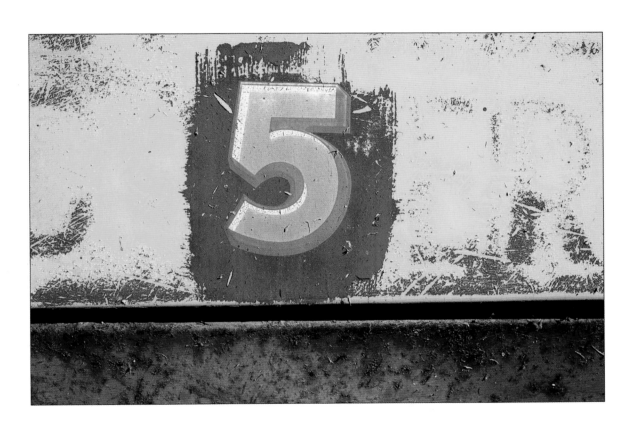

Rockyford, Alberta, 2013

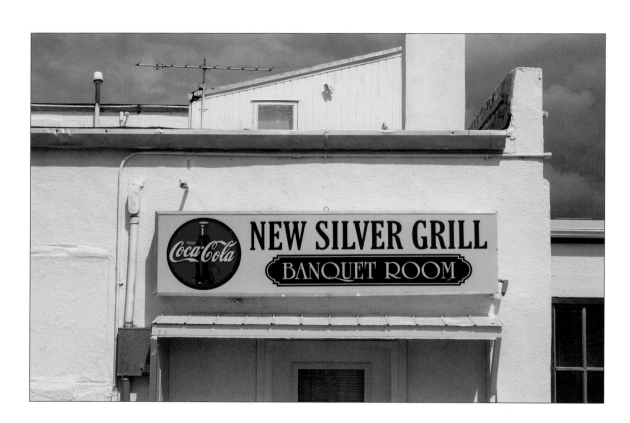

Fort Macleod, Alberta, 2009

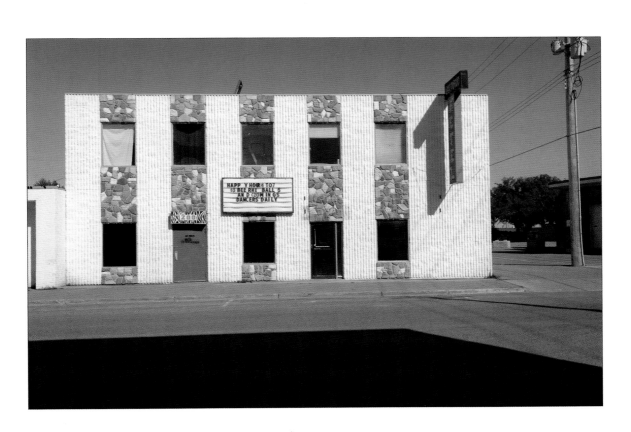

Brooks, Alberta, 2011

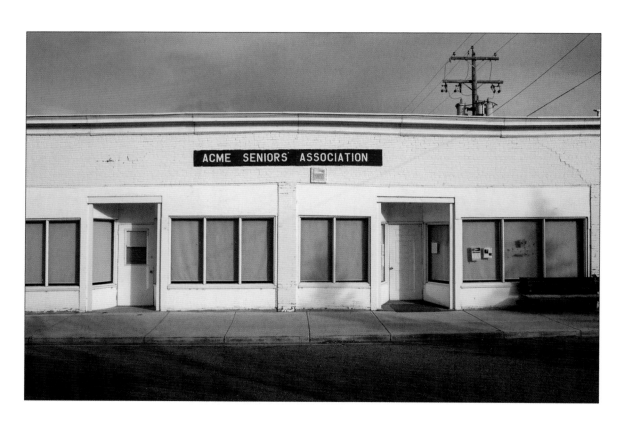

Acme, Alberta, 2010

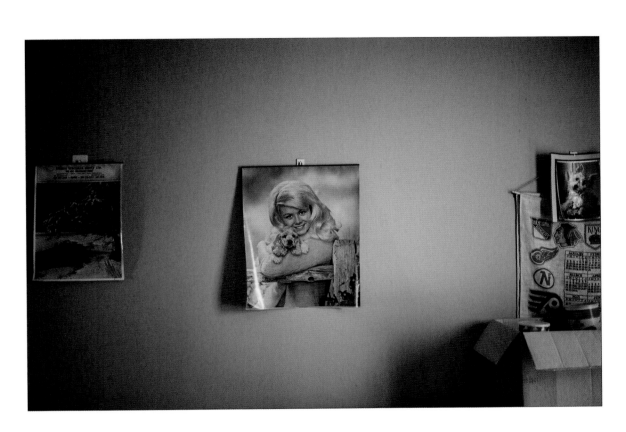

Orion, Alberta, 2012

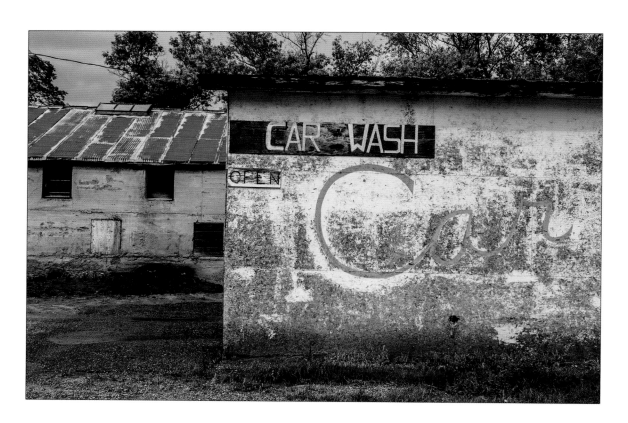

Milk River, Alberta, 2004

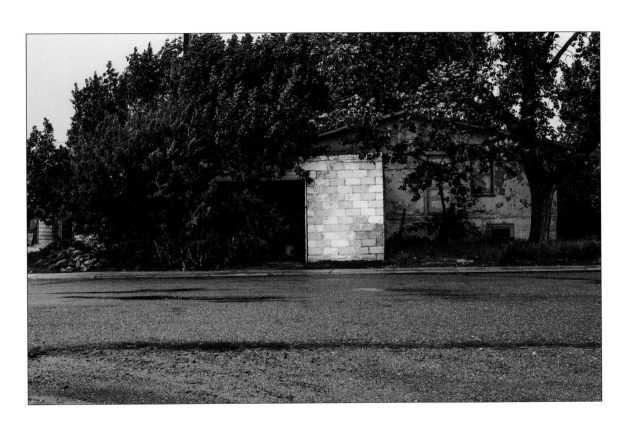

Milk River, Alberta, 2008

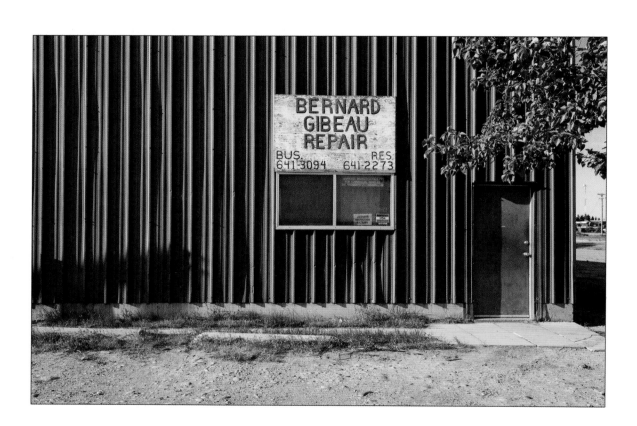

Bassano, Alberta, 2011

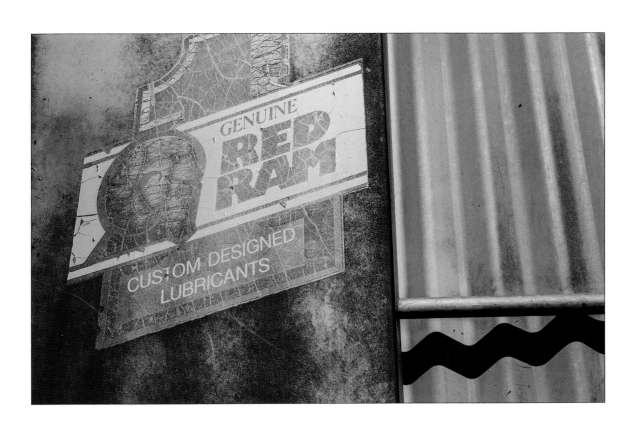

Barons, Alberta, 2012

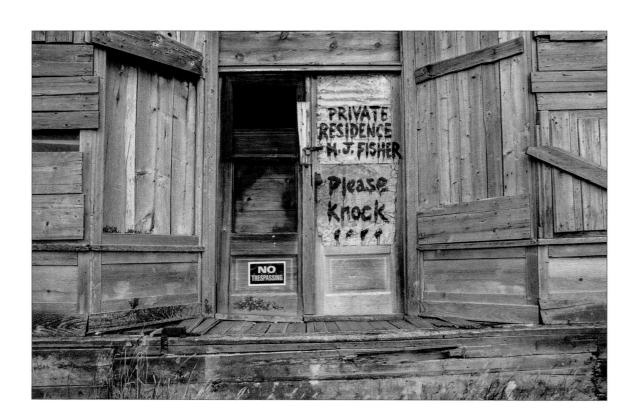

Winnifred, Alberta, 1987

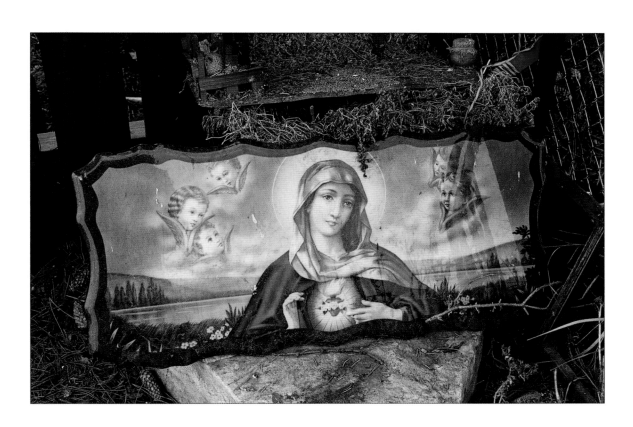

Edmonton, Alberta, 2016

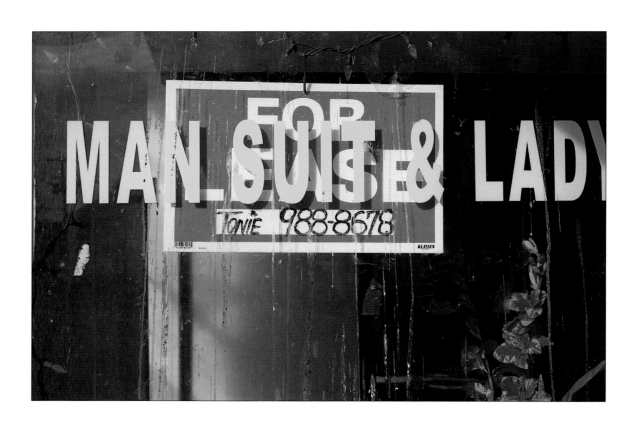

Edmonton, Alberta, 2016

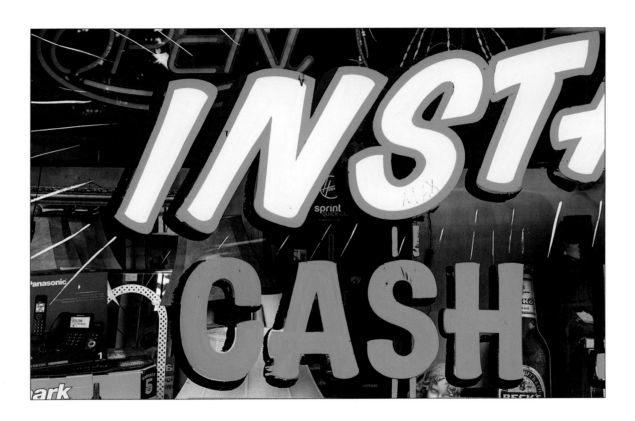

Edmonton, Alberta, 2016

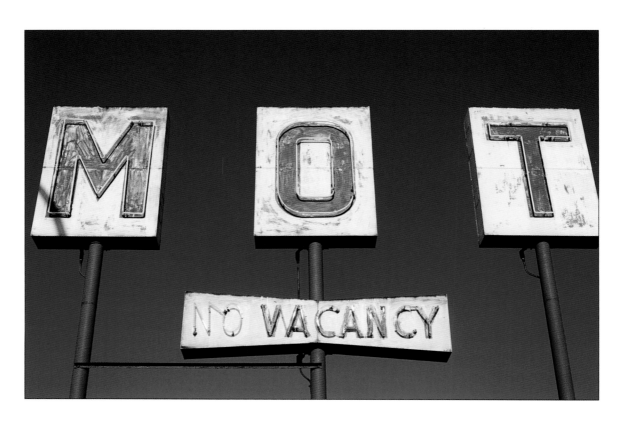

Edmonton, Alberta, 2017

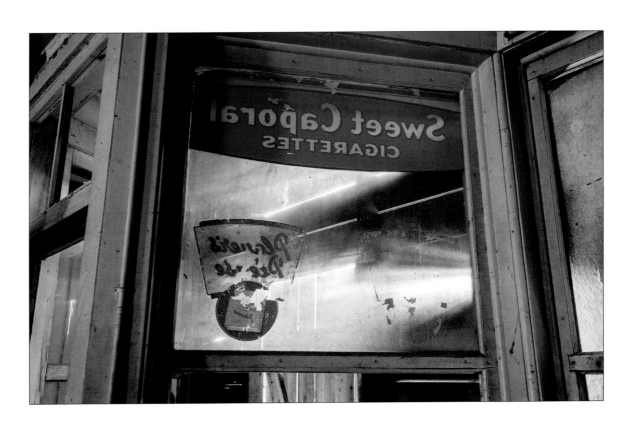

Bindloss, Alberta, 2012

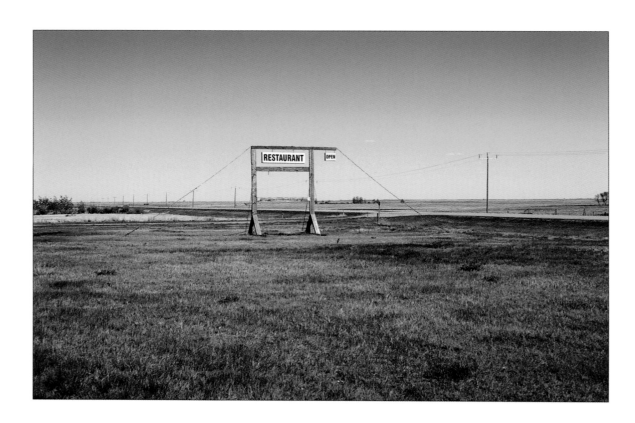

Scotfield, Alberta, 2018

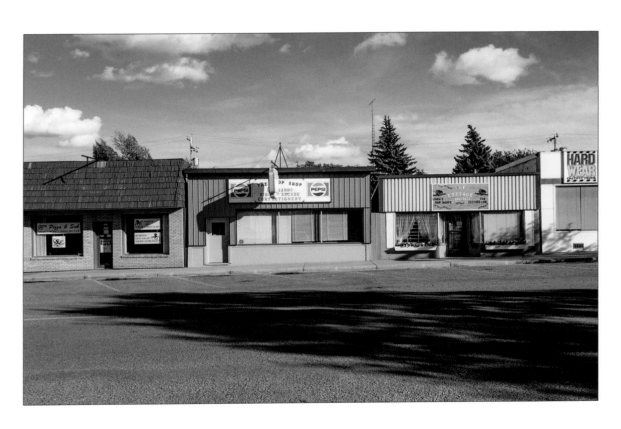

Vulcan, Alberta, 2004

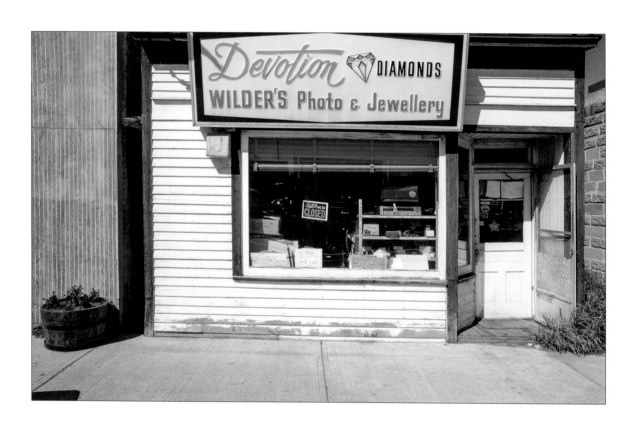

Hardisty, Alberta, 1986

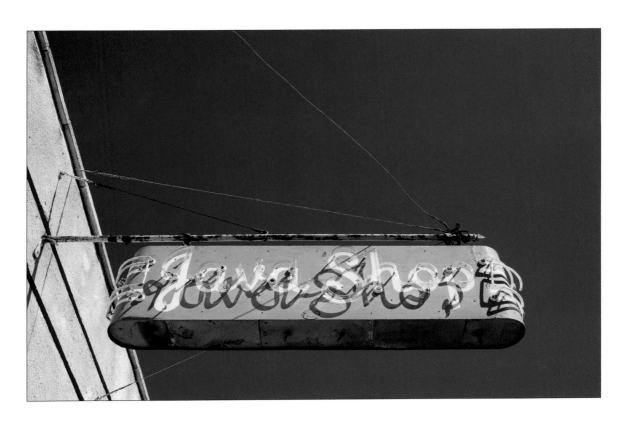

Fort Macleod, Alberta, 2012

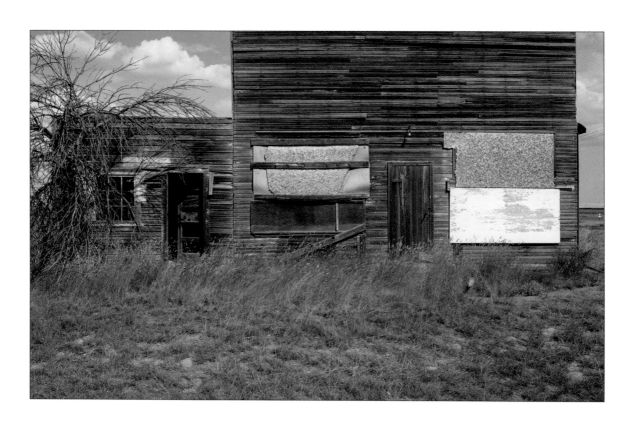

Bindloss, Alberta, 2012

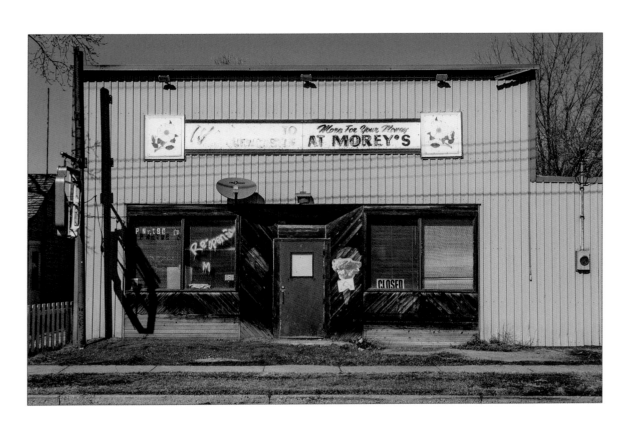

Newcastle, Alberta, 2008

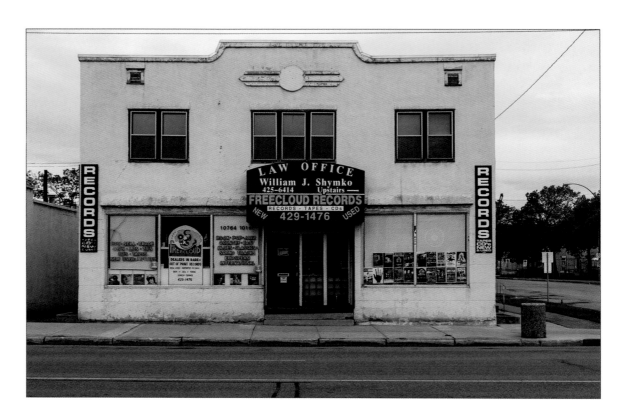

Edmonton, Alberta, 2008

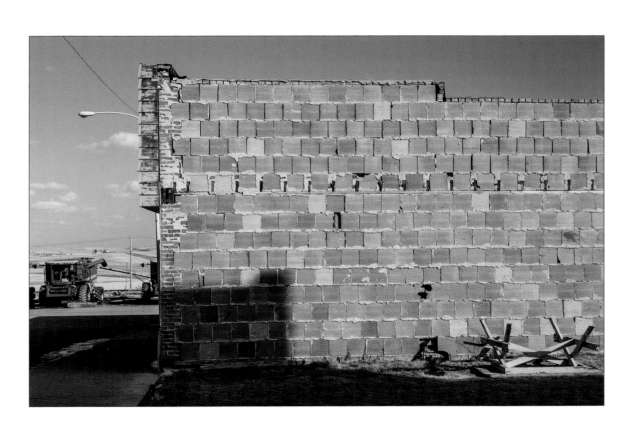

Trochu, Alberta, 2008

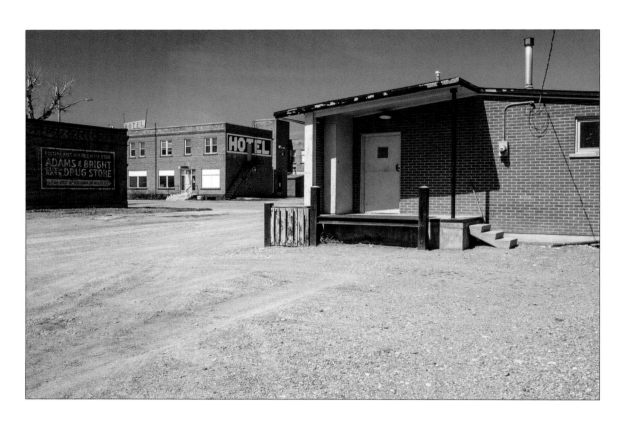

Stavely, Alberta, 2003

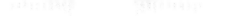
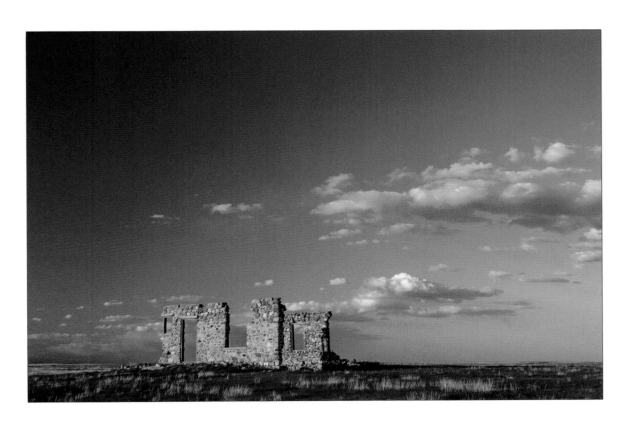

Near Wardlow, Alberta, 2010

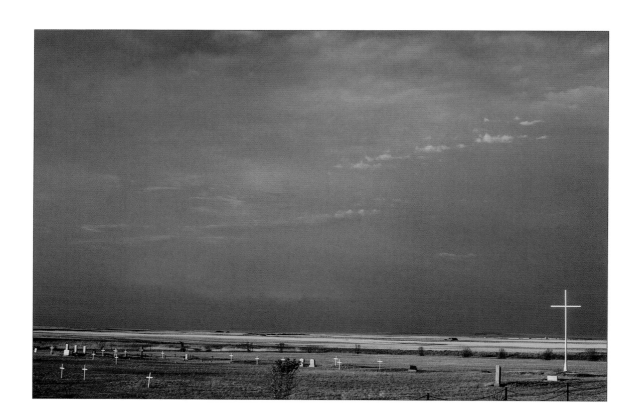

Near Foremost, Alberta, 2008

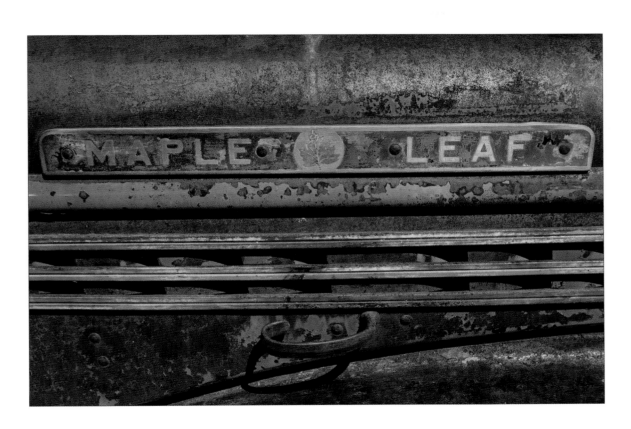

Chin, Alberta, 2012

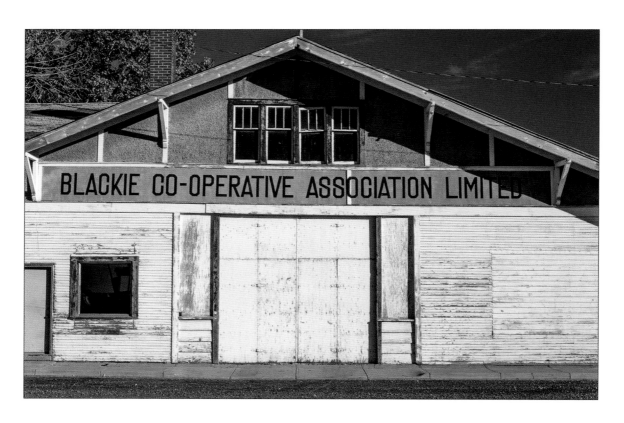

Blackie, Alberta, 2001

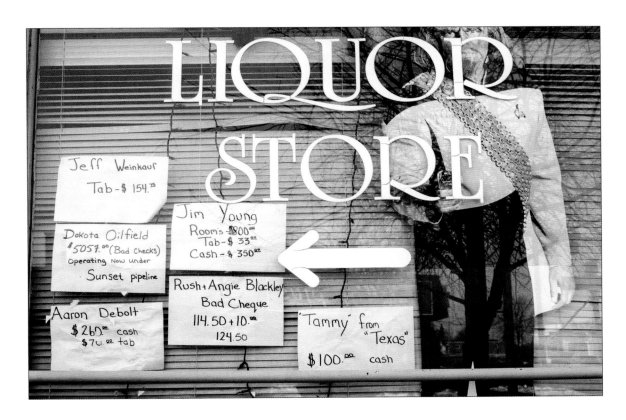

Vulcan, Alberta, 2002

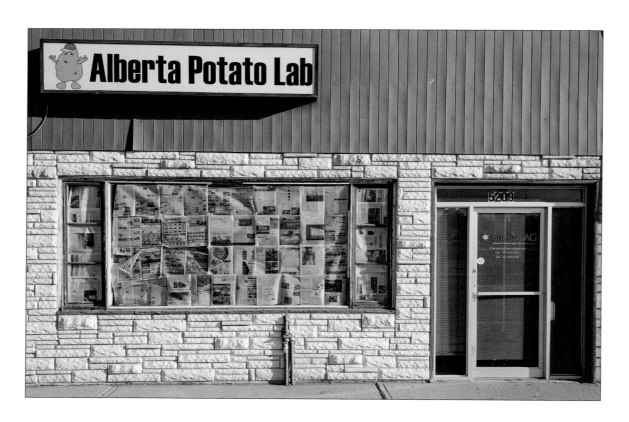

Taber, Alberta, 2012

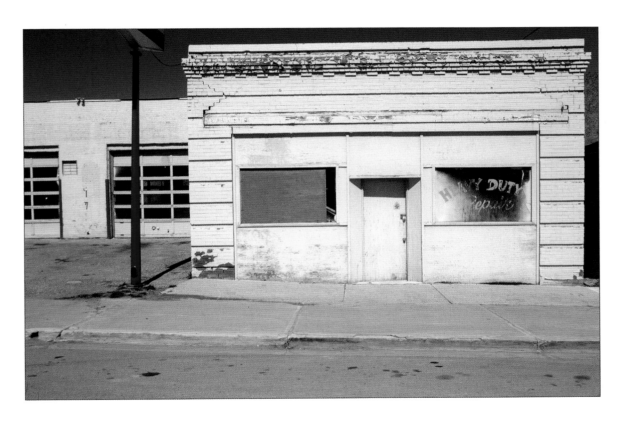

Stavely, Alberta, 2003

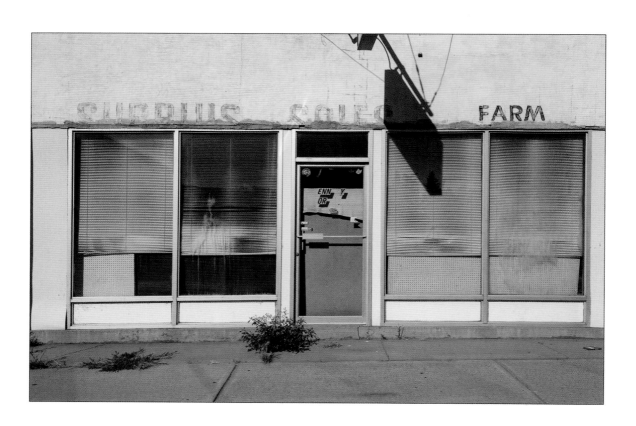

Camrose, Alberta, 2011

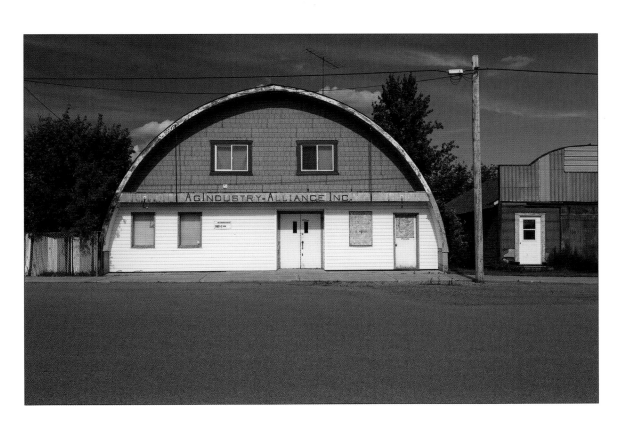

Alliance, Alberta, 2011

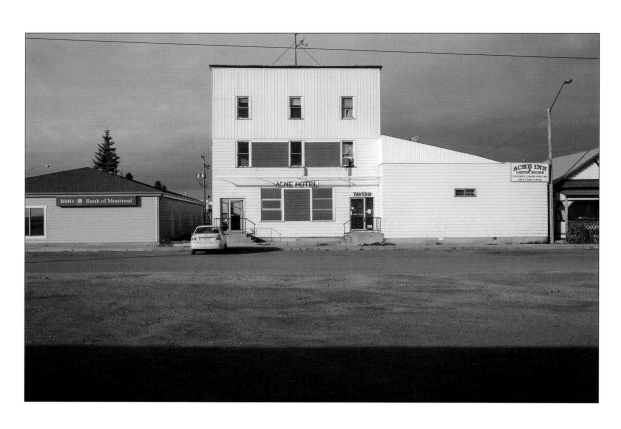

Acme, Alberta, 2010

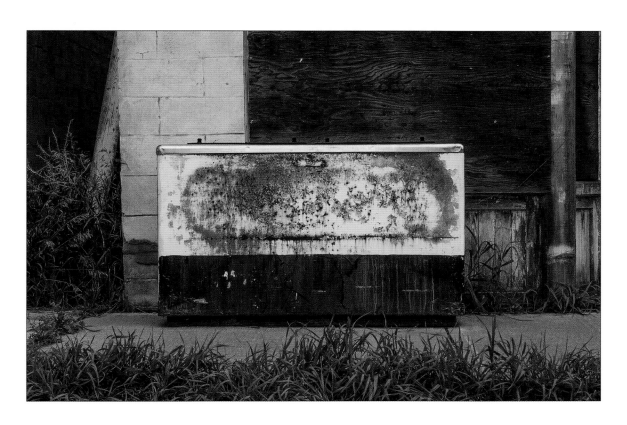

Hairy Hill, Alberta, 2007

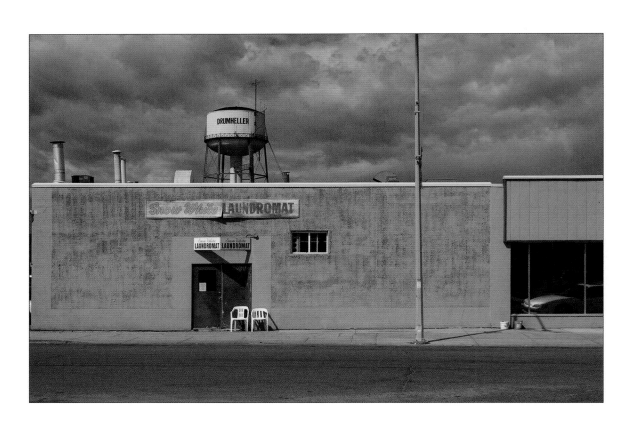

Drumheller, Alberta, 2009

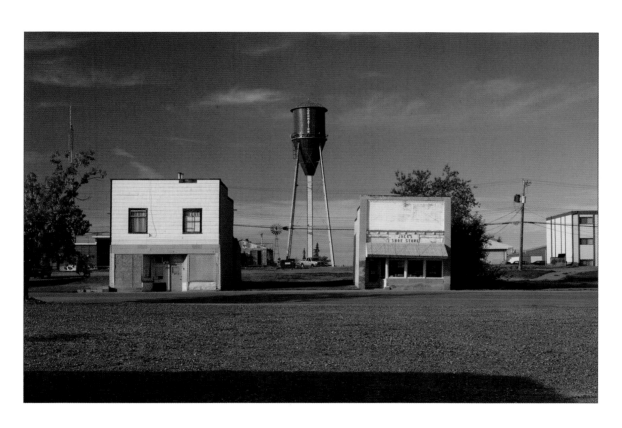

Coronation, Alberta, 2007

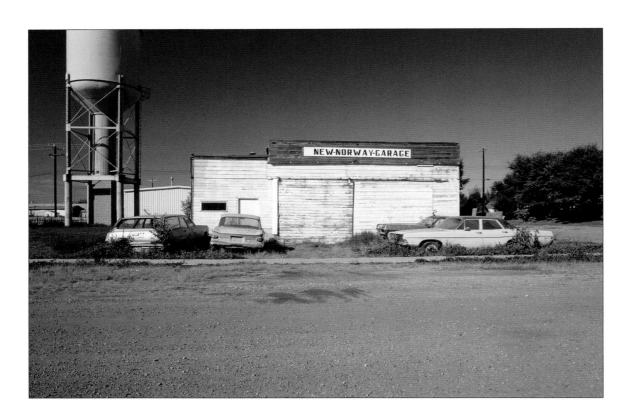

New Norway, Alberta, 1986

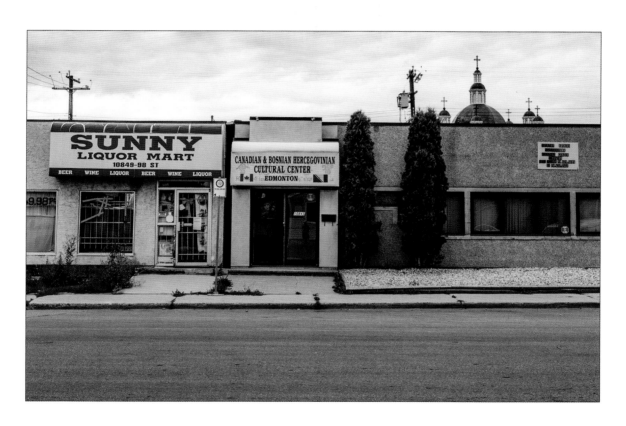

Edmonton, Alberta, 2008

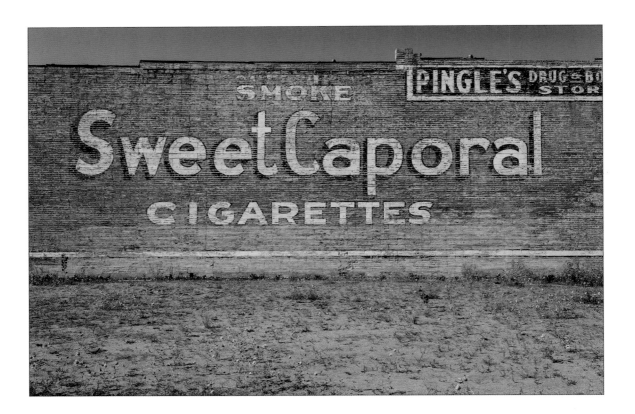

Medicine Hat, Alberta, 2012

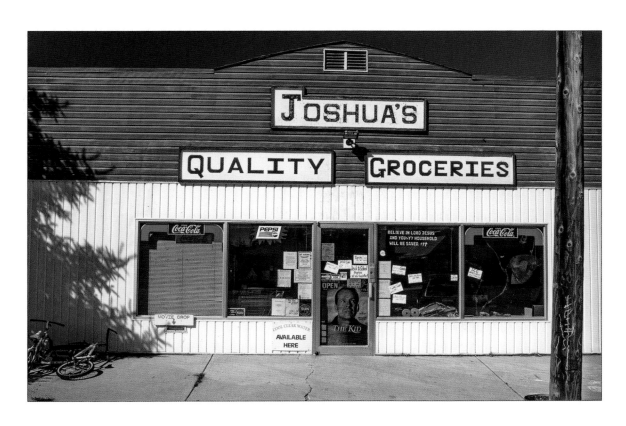

Champion, Alberta, 2002

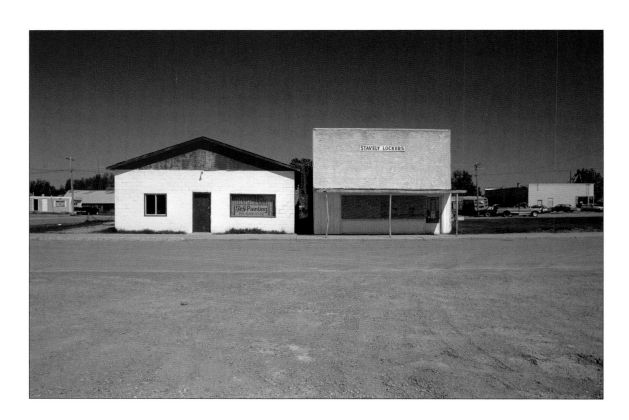

Stavely, Alberta, 1993

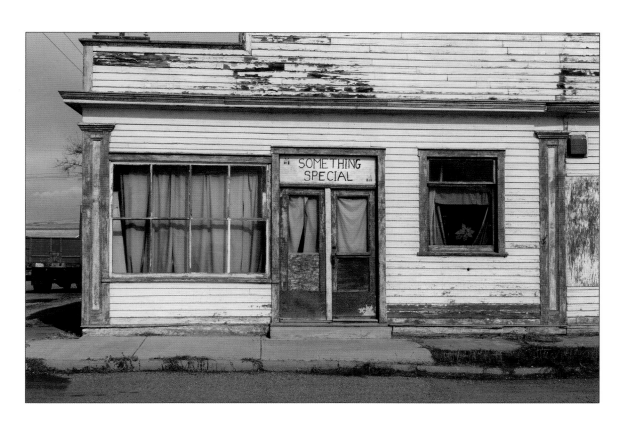

Hussar, Alberta, 2008

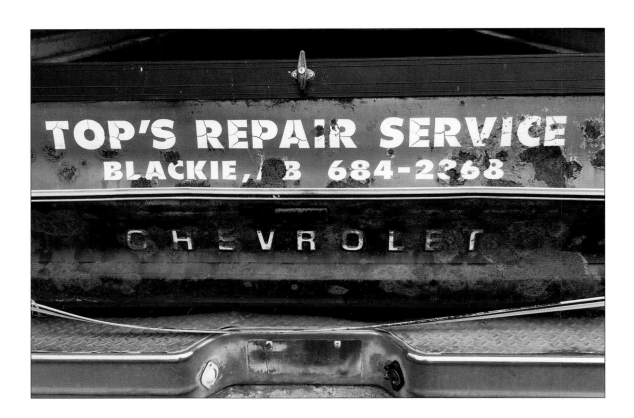

Blackie, Alberta, 2004

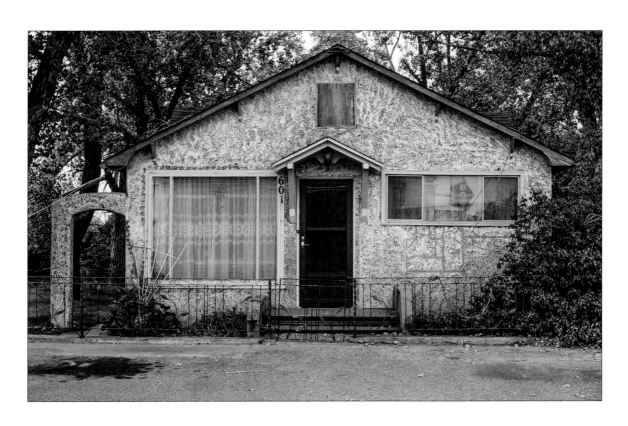

Bow Island, Alberta, 2001

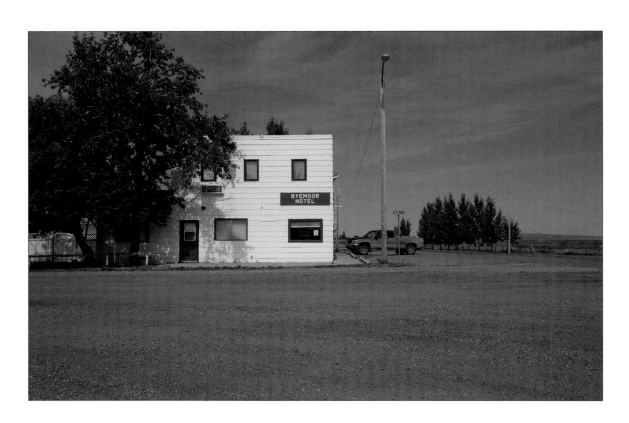

Byemoor, Alberta, 2011

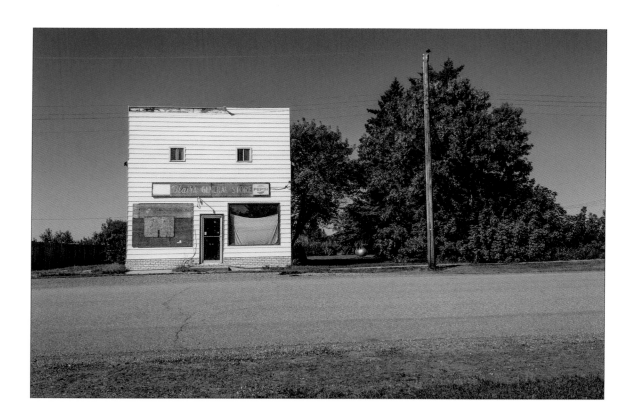

Lousana, Alberta, 2011

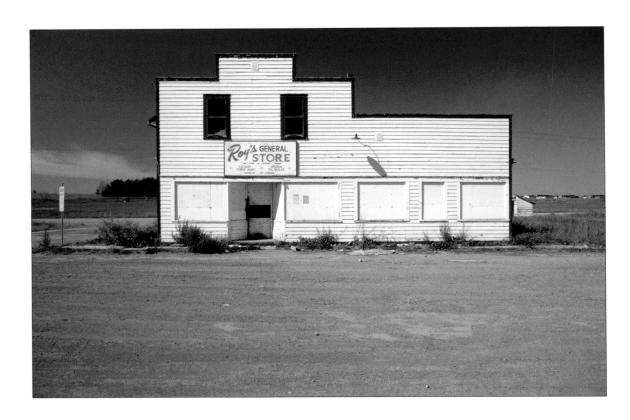

Hobbema, Alberta, 1986

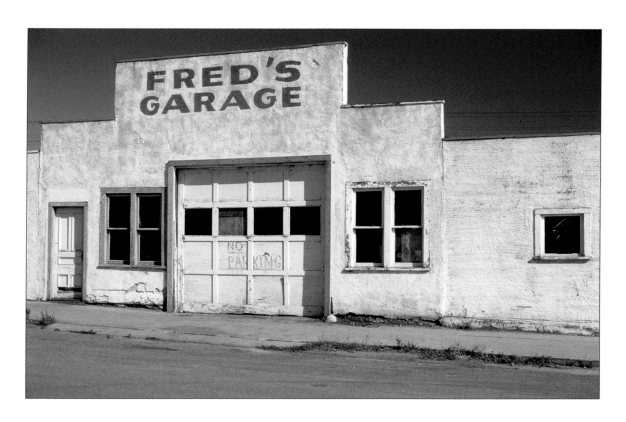

Delburne, Alberta, 1981

GEORGE WEBBER is a renowned documentary photographer whose previous books include *Badlands*, *Prairie Gothic*, *In This Place*, *Last Call*, *People of the Blood*, *A World Within*, and *Requiem*. His photographs have been featured in *American Photo*, *Canadian Geographic*, *Lenswork Quarterly*, *Photolife*, *The New York Times* and *Swerve* magazine. In 1999 he was elected to the Royal Canadian Academy of Arts in recognition of his contributions to the visual arts in Canada, and in 2018 he was awarded Canada's National Magazine Gold Award for Photojournalism. George lives in Calgary, Alberta.

FRED STENSON is a novelist, non-fiction writer and film writer. His most recent books include *Who By Fire*, *The Great Karoo*, *Lightning*, and *The Trade* (finalist for the prestigious Giller Prize and nominated for the IMPAC Dublin Award). Stenson was a founding member of the Writers' Guild of Alberta and has been on the council of The Writers' Union of Canada three times. Since 2001 he has been director of the Wired Writing Studio at Banff Centre. He has been the humour columnist for *Alberta Views* magazine since its inception in 1999. Fred lives in Cochrane, Alberta, with his wife, Pamela Banting.

ROSEMARY GRIEBEL grew up on the prairies and started writing poetry as soon as she could start forming letters on a page. She is currently Design Lead for Readers' Services at the Calgary Public Library, where she has worked for 20 years. Rosemary's poems have won numerous awards and her first book of poetry, *Yes*, was published in 2011. Rosemary lives in Calgary, Alberta.

RMB | Rocky Mountain Books Ltd.
rmbooks.com
@rmbooks
facebook.com/rmbooks

Cataloguing data available from Library and Archives Canada
ISBN 9781771602976 (hardcover)

Printed and bound in China by 1010 Printing International Ltd.

Distributed in Canada by Heritage Group Distribution and in the U.S. by Publishers Group West

For information on purchasing bulk quantities of this book, or to obtain media excerpts or invite the author to speak at an event, please visit rmbooks.com and select the "Contact Us" tab.

RMB | Rocky Mountain Books is dedicated to the environment and committed to reducing the destruction of old-growth forests. Our books are produced with respect for the future and consideration for the past.

We acknowledge the financial support of the Government of Canada through the Canada Book Fund and the Canada Council for the Arts, and of the province of British Columbia through the British Columbia Arts Council and the Book Publishing Tax Credit.